Watercolor Lettering

A Step-by-Step
Workbook for Painting
Embellished Scripts
and Beautiful Art

JESS PARK

ULYSSES PRESS

Dedicated with love to Andrew (my rock) and Harper (my heart)

Published in the United States by:
Ulysses Press
P.O. Box 3440
Berkeley, CA 94703
www.ulyssespress.com

ISBN: 978-1-61243-834-4
Library of Congress Control Number: 2018944079

Printed in the United States by Versa Press
10 9 8 7 6 5

Acquisitions editor: Bridget Thoreson
Managing editor: Claire Chun
Editor: Shayna Keyles
Proofreader: Renee Rutledge
Front cover design: Ashley Prine
Cover art: © Jess Park
Interior design: Jake Flaherty

Contents

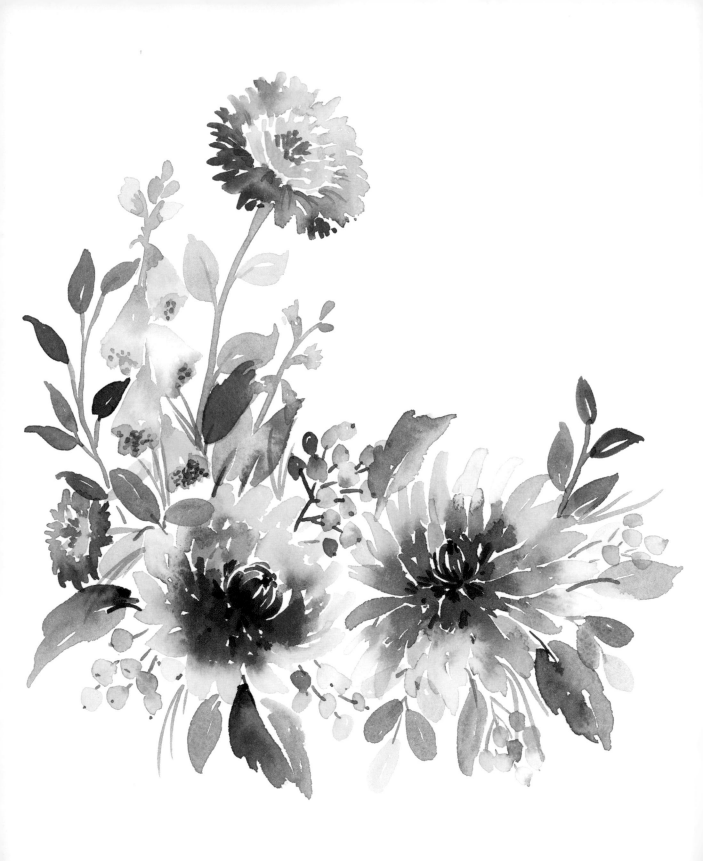

Introduction

When I was a little girl, my late grandmother would walk me to and from my art classes. During one of these walks, she told me about the time she entered a painting of pomegranates into an art contest and won first prize. She was just a young girl—a little older than I was at the time. Her story surprised me, as it was the first time she had ever mentioned to me that she painted. At the time, it made me feel like I had art in my blood, coursing through my veins. But mostly, it warmed my heart to share this special bond with my grandmother. This story has stayed with me throughout my art career.

Watercolor is like an old friend. I love trying new media, but I always come back to watercolor. The tapping of the brush on the glass of water, the smell of the paint, the way the paper feels—it's all familiar and comfortable. It brings me back to the days I painted as a little girl.

But at the same time, watercolor is unpredictable and exciting. You never know how a wash will settle or blend. I love that I can paint the same subject multiple times, but it will look and feel different depending on my mood. The days I feel frustrated, I'll produce something that looks overworked. The days I sit down more at peace, my work will look loose and free. And every once in a while, I'll get a happy accident or a blend within a painting that is just so perfect.

I'm excited to share my love and knowledge of watercolor with you, through both painting and lettering. I hope the following pages better acquaint you with my dear old friend.

Love,

Jess Park

* * *

Getting Started

Though watercolor and lettering have been around for some time now, there has been a recent popularity surge in loose watercolor and modern lettering, and in combining the two techniques. But starting a new hobby combining the two can be confusing. Which supplies should you start with? What are the things you absolutely need, and which items are purely supplemental? In this chapter, you'll learn about all the different supplies you'll need for lettering and watercolor lettering.

LETTERING SUPPLIES

PAPER

You want several different types of paper: for practicing, for lettering only, and for projects that combine watercolor and lettering.

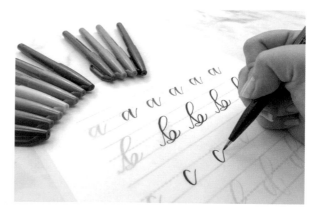

TRACING PAPER. Semi-transparent and smooth, this paper is perfect when first starting out. I recommend using tracing paper to practice the different strokes and letters in Chapters 5, 6, 7, 8 and 9 of this book. The smooth finish is easy on your brush pens and the transparent quality allows you to see the underlying exemplars. In addition, using tracing paper allows you to practice over and over.

PRACTICE PAPER. I recommend using a smooth finish paper such as a Rhodia pad when practicing lettering. The smooth finish allows for ease of movement as well as protecting your brush pens against damage. HP Premium Laser Jet (32 lb.) Printer Paper or Hammermill Color Copy Digital (32 lb.) are

alternatives that are not quite as smooth but are more economical. I use these printer papers when I'm just practicing or loosening up.

MARKER PAPER. Marker paper also has a smooth vellum-type finish and is thicker than the previously mentioned papers. It can be used for blending brush pens without fraying your pens. Because it is a thicker paper, it can be used for final products.

VELLUM PAPER. Vellum paper is similar to tracing paper but more elegant and may be less translucent. It can be used with just lettering, or with a combination of print and lettering. Another way it can be used is over a watercolor painting. It softens the colors of the painting and adds an elegant touch. It is also perfect for those who are nervous about lettering over a painting.

WATERCOLOR PAPER. See page 10.

PENS

With the amount of brush pens available for lettering, there could probably be a whole chapter devoted to them. To keep things simple, I have divided the pens into two broad categories: small tip and large tip. In addition, I only include information on the ones I typically use. I rarely use large-tip brush pens in combination with watercolor, as the rough paper tends to ruin these pens. However, for the sake of completeness, I have included information on them in this section.

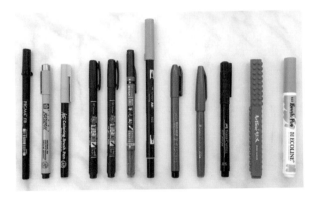

Remember that like paint and paintbrushes, picking a brush pen that works for you is a personal choice. What works for me may not be ideal for you. Many are sold individually so I recommend trying out a few and seeing which you like best.

SMALL-TIP PENS

Small-tip pens produce fine lines and are used for small-scale lettering. Some are waterproof like the Tombow Fudenosuke Brush Pens (hard and soft), Faber Castell Pitt Artist Brush Pens (which also have archival ink and come in various colors), Sakura Pigma Professional Brush Pens (which have archival ink), and the Zebra Disposable Brush Pens. This means you can letter first and then paint over the lettering without worrying that the ink will bleed. The latter two also come with various sized tips. Others, like the Pentel Fude Touch Sign Pens, come in various colors but are not waterproof.

I recommend that beginners start out with a small-tip pen for three reasons:

1. **Durability:** Small-tip pens do not fray as easily as the large-tip pens. When starting out, you are still getting used to how hard to press to produce a thick downstroke. As a result, many beginners press a little too hard. These pens can take a lot of abuse before they begin to fray.

2. Control: Small-tip pens have short tips that are easier to control. The small tip *is* flexible, but not so much that it is difficult to handle.

3. Size: The larger the pen tip, the larger the resulting writing. Larger writing requires larger arm movements that can be more difficult to grasp as a beginner. Smaller-tip pens can write in the size you are more familiar with—the size you would write with a normal ballpoint pen.

These are my favorite small-tip pens:

- Tombow Fudenosuke Hard and Soft Brush Pens
- Tombow Twin Tip Brush Pen
- Pentel Fude Touch Sign Pen

LARGE-TIP PENS

Large-tip pens produce larger-scale lettering. They are typically water soluble, meaning you can blend colors together with water or a blending pen. Most large-tip brush pens come in a variety of colors as well. Some of my favorites include Sakura Koi Coloring Brush Pens, Royal Talens Ecoline Brush Pens, Tombow Dual Brush Pens, and Artline Stix Brush Marker Pens. All of these brush pens can be used on their own or dipped into liquid watercolor for a blending effect. One of the main differences between these pens that you may notice is the barrel of the pen. It's important to understand that it is not just a design difference—the barrel of the pen can affect your lettering:

- **Length:** Longer pens can cause excessive movement for those with smaller hands, making them difficult to control.
- **Width:** A barrel that is too thin or too thick for your hand can cause issues with grip.
- **Comfort:** Some pens have a textured design that can cause discomfort with prolonged use.

As with everything, it is a personal preference and there is no "right" or "wrong" pen. See what feels most comfortable to you.

My favorite large-tip pen is the Sakura Koi Coloring Brush Pen. The size of the pen is perfect and I love the amount of flexibility in the tip. It is also very versatile and I often use the water-soluble ink to make faux watercolor backgrounds.

FINE LINER PENS

Fine liner pens are used for mono-line lettering (lettering with strokes that don't vary in thickness). I also like to use them to touch up lettering done on watercolor paper. Because of the texture of watercolor paper, lettering over this type of paper may leave bumpy edges, and I like to touch them up with fine liners. My two favorites are:

- **Sakura Pigma:** All Pigmas have archival ink that doesn't bleed. This is one of the reasons these are my go-to pens for all professional work that requires ink. The pens are available in various colors with

many different sized tips (Microns are as small as 0.15mm and Graphics go as thick as 3mm). I also like to use the Pigma Graphic Liner (which has a bullet tip) with my watercolor work.

- **Tombow Mono Drawing Pen:** The Mono Drawing Pens are a newer line of pens that also have archival qualities. The manufacturer recommends allowing the ink 2 minutes to dry before painting over it. The pens come in three different sized tips.

PAINT

Though I do often use tube and pan paint when lettering with watercolor, I prefer to use liquid watercolor. The main reason is convenience. Without diluting, the ratio of liquid to pigment remains consistent, which makes it easier to blend without hard edges forming. Some brands, such as Ecoline by Royal Talens or Dr. PH Martin's, carry a myriad of colors. This eliminates the need to mix new colors— meaning I can start a project, take a break, and come back without trying to reconstitute dry paint, or re-mix the same color. See page 15 for more on paints.

DR. PH MARTIN'S BLEED PROOF WHITE: Though not necessary, Dr. PH Martin's Bleed Proof White is a product many calligraphers have in their arsenal of lettering supplies. It is a highly concentrated opaque watercolor that can be diluted to use with a brush, or even with a nib. It can be used to letter or paint and because it is opaque, you can use it to letter over your paintings. A suitable alternative to Bleed Proof White would be white gouache.

METALLIC WATERCOLOR: Metallic watercolors add beautiful accents to watercolor paintings and can also be used to letter. My favorites include Coliro Finetec and Kremer Pigmente watercolors. Just like any other watercolor, you must first wet the paint and allow it to sit for a minute before using. You may find that the paint is a bit thicker than regular watercolor and requires a bit more water and rewetting than you're accustomed to.

WATER BRUSHES

A water brush looks like a paintbrush, but the brush hairs are typically synthetic and the handle is a plastic barrel that can be filled with liquid, such as water, liquid watercolor, or ink. Squeezing the barrel allows water to wet the brush, eliminating the need for a container of water. This makes it perfect for *plein air* painting (painting outdoors/ outside of a studio setting). For watercolor brush lettering, a water brush eliminates the need to con-

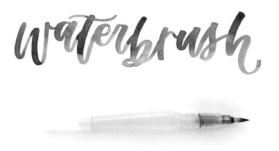

stantly redip. The brushes can also be used to create interesting ombré effects. Early on in my lettering career, this type of brush is what led me to fall in love with watercolor lettering.

My favorite water brushes include the Pentel Aquash water brushes as well as the Caran d'Ache fiber/felt tipped water brush. The Caran d'Ache brush is interesting because the tip is more like a bullet-tip marker than a brush. This means you can write mono lines or apply pressure to create both thick and thin lines.

BRUSHES

If you'd prefer to use a regular brush for watercolor lettering, you want to stick with a round or liner brush. A smaller brush will make it easier to create delicate lines while a larger brush would be used for larger lettering pieces. In general, I don't use anything larger than a round 6 for lettering. To pick a good brush for lettering, you want something that has a lot of snap and that keeps its bristles together even when making a tight curve. If a brush is too flexible, it will be difficult to control. See page 12 for more on brushes.

GETTING STARTED

To get started, all you need is a Tombow Fudenosuke Hard Brush Pen, tracing paper (to trace fundamental forms and letters), and a Rhodia grid or dot pad (to practice on your own without tracing).

If you decide to start with watercolor lettering, then watercolor paint, watercolor paper, and a water brush or a round size 2 paintbrush would work well.

WATERCOLOR SUPPLIES

PAPER

For the watercolor exercises in this book , I recommend using Arches 140 lb. cold press watercolor paper, unless otherwise specified. I also recommend using Winsor and Newton (WN) and Daniel Smith (DS) paints, as well as Princeton Heritage (PH) brushes. All recommended colors and brush sizes are listed before each exercise. Remember, it is not necessary to have the exact colors or brush sizes to achieve the same effects. Use what you have that is the closest.

Paper is the most important supply to consider for watercolor painting. This is because the type of paper you use affects the way the pigments settle, blend, and move across the paper.

These are the paper types that I use most frequently:

- Arches Cold or Rough Pressed 140 lb. for professional watercolor paintings. This paper is recommended for most projects in this book.

- Strathmore 400 Series Cold Press Paper for *plein air* painting. Though this is not a 100% cotton paper, it is travel friendly, economical, and comes in convenient sizes and in wire binding, making it easy to carry around.

- Legion Paper Stonehenge Aqua Coldpress for professional mixed media (watercolor and ink). It has a slightly smoother finish than Arches. This paper is occasionally suggested for projects that benefit from a faster drying time.

Watercolor paper is generally categorized by weight and pressure/texture.

WEIGHT. The weight of all paper is measured in both pounds (lb.) and in grams per square meter (gsm). Generally, you'll see watercolor paper available in 90 lb. (200gsm), 140 lb. (300gsm), and 300 lb. (640 gsm). The heavier the paper, the thicker it will be. Anything below 140 lb. will buckle excessively with the addition of water. Whether you are lettering or painting, I would advise using paper that is at least 140 lb.

PRESSURE/TEXTURE. Watercolor paper is categorized into three pressures: rough, cold, and hot. The more compressed the fibers of the paper, the smoother the finish, and the less space there is for water to penetrate and be absorbed.

- **Rough:** The least compressed of the three. The paper has a more textured surface, making it ideal for dry brush strokes. The rough surface allows for smoother washes and blends, and is good for glazing (layering paint).

- **Cold:** Cold press is a middle ground between rough and hot, and is ideal for most watercolor paintings. It allows for washes and dry brush strokes, and is good for scraping. I would recommend using cold press paper for the exercises in this book.

- **Hot:** The most smooth and compressed, and therefore, least absorbent of the three. Water sits on the surface, resulting in more unpredictable washes. It is difficult to control paint and washes on hot pressed paper.

MODALITIES

The most common modalities that watercolor paper comes in are pads, blocks, or individual sheets. There is no best modality, but there are definitely advantages for each. Pads of watercolor paper are useful if you want to keep all of your paintings together in one place. You can also work on more than one painting at a time if you work on a pad of paper. A block of paper is a modality where the paper is glued down on most or all four sides, which allows the painting to dry flat. However, you can only work on one painting

Rough press

Cold press

Hot press

in a block at a time. Pads and blocks are good for *plein air* painting. Lastly, you can work on individual sheets of watercolor paper, but you will need to tape them down on all sides or stretch the paper to ensure your paintings dry evenly.

PAPER COLOR

The color of your paper is very important due to the transparent quality of watercolor paint. Watercolor paper is usually a natural white color with a subtle cream tone. Some companies offer different colors of watercolor paper, the most common being bright white. Others even offer blue or gray paper. Whichever paper you choose, the color of the paper will show through your paint. You can use this to your advantage to create different effects.

BRUSHES

With so many sizes and shapes of brushes, it's hard to know what to purchase and when to use each brush. Whatever the shape, a quality brush will have soft and springy hairs, and have the ability to keep its shape when wet. The brush will both readily soak up water and release pigment. The highest quality brushes are those made up of natural hair, such as Kolinsky sable hair brushes. You will also see brushes made of squirrel, goat, ox, and other animal hairs. But synthetic blends and synthetics are also great economical alternatives, especially when starting out.

ANATOMY OF A BRUSH

HANDLE: Typically made of wood, plastic, or bamboo. This is the portion of the brush you want to hold when painting. The handle is usually where you can find information about the size, shape, and manufacturer of a brush. Watercolor brushes generally have shorter handles compared to those for other media, such as oil.

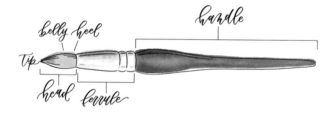

FERRULE: Usually metal but can be plastic (commonly seen in mop brushes). This is the portion of the brush that holds the hairs in place and connects the head of the brush to the handle. Don't wet your brush past the ferrule.

HEEL: This is the portion of the brush that you might use for scrubbing paint. With repeated use, pigment can build up at the heel of the brush, so be sure to rinse after every use.

BELLY: Also called the reservoir, this part of the brush is the thickest and holds most of the water.

TIP/TOE: The thinnest part of the brush. This is the portion of the brush used to make thin, detailed lines.

HEAD/TUFT: Includes the heel, belly, and tip of the brush.

To test a round brush, wet the hairs of the brush and gently press the belly down onto paper or a towel. Release pressure. Do the hairs spring back into shape or do they lose their point? Are any hairs out of place? A good brush should maintain its point, retain a fair amount of water, and gradually release water when painting.

BRUSH SHAPES

ROUND: This is the most versatile and commonly used brush shape. If you were to only get one shape of brush, this would be it. I love this shape because the belly of the brush allows for big swells while the tip allows for thin lines. Depending on the manufacturer, round brushes generally come in size 000 (3/0) to 24. For painting, I recommend having at least three sizes, such as 2, 6, and 10. For lettering, start with smaller sizes, such as 1 or 2.

FLAT: There are several watercolor brushes with flat ferrules (hake, flat, angular, square flat, and fan). With the exceptions of the fan, used for textures such as grass, and the angular brush, used for detail and curves, flat brushes can be used for large washes or thin strokes, depending on how the brush is held.

LINER/RIGGER BRUSH: Thin and flexible, these brushes are used for details, long continuous lines, and for lettering. For a beginner, a liner brush may be difficult to control.

MOP: Extremely absorbent and flexible, mop brushes are generally used to wet large areas of paper or for larger paintings.

WATER BRUSH: See page 9.

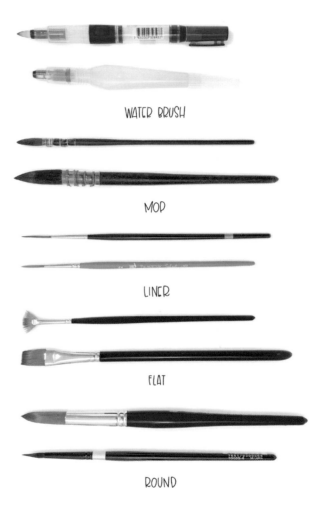

WATER BRUSH

MOP

LINER

FLAT

ROUND

BRUSH SIZE

Smaller brushes are used for fine detail while bigger brushes are used for large areas. When purchasing brushes, buy at least one large, one medium, and one smaller brush. For example, when painting a landscape, you'd use the larger brush for the background, such as the sky. Using a smaller brush would result in an uneven wash. The medium brush might be for the basic shape of a tree. And the small brush could be used for leaves and other details.

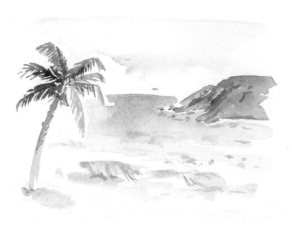

I used three different sized brushes for this landscape painting. The sky and ocean were painted with a larger brush. The cliff, the details of the ocean waves, and palm fronds were painted with a medium-sized brush. The little birds were painted with a very small brush.

BRUSH CARE

PREPPING YOUR BRUSH. When purchasing a new brush, there is usually a stiff coating over the hairs to help maintain the shape while protecting them from breakage and damage. Before first use, give your brush a thorough, but gentle, rub, and rinse under running water to remove the coating. Take care not to bend the hairs before prepping, as this can lead to breakage.

STORAGE. The most sure-fire way to ruin your brushes is to keep them submerged in a container of water after use. The water will break down the glue that holds the ferrule and handle together. The hairs may be permanently bent and lose their shape and point. To store a brush after use, simply rinse with clean water. Shake to remove excess water and gently reshape the brush hairs. Lay the brush flat horizontally to dry, or at an angle with the brush head lower than the handle. This is to prevent excess water from entering the ferrule. Once dry, store upright with the brush hairs facing upward.

CLEANING. After repeated use, a brush may collect pigments in its hairs. To remove the pigments, clean with mild soap in the same manner as you would when prepping a brush. Do not use hot water with natural hair brushes, as this may remove the oils from the hairs.

HOW TO CHOOSE A BRUSH

Like many other aspects of watercolor, the answer to this question heavily depends on personal preference. Some artists enjoy more flexibility, while others prefer to work with a stiffer brush. Try a few brushes from different companies and see what feels most comfortable to you. After you purchase a brush, play around with it to test its capabilities: What lines and textures will it create? How well can it hold water?

My favorite natural-hair brushes are my Raphaël 8404 series Kolinsky Sable Brushes. For synthetics, my go-to brushes are the Princeton Heritage 4050 series and the Princeton Elite 4850 series.

HOW TO HOLD A WATERCOLOR BRUSH

Though your grip may change with the types of strokes you create, generally, you want to hold a watercolor brush much like you would a pencil or a pen, but further back along the handle. Hold the brush at the thickest part of the handle, or as close to this area as you can. For tight detail work, you may hold it close to the end of the ferrule, but definitely not near the brush head as you would a pencil. Holding it too close restricts movement, resulting in paintings that may look overworked.

PAINT

Watercolor paint consists of two main ingredients: pigment and a binder. Pigment gives the paint its color. It can be derived from minerals or organic material. Gum arabic, the binder in watercolor, is what causes the pigment to adhere to the paper. The translucent and water-soluble qualities of gum arabic make it the perfect vehicle for this medium.

The majority of my watercolor paints are Winsor and Newton and Daniel Smith professional-grade tube watercolors. For lettering, I use Royal Talens Ecoline liquid watercolors for a smooth blend, and Kremer Pigmente and Coliro Colors Finetec for their metallic colors. I enjoy comparing, adding, and switching out colors every so often.

PROFESSIONAL VS. STUDENT GRADE PAINT

Watercolor can be divided into two categories: artist/professional and student grade. Professional grade watercolors contain high-quality pigments at a higher concentration, while student grade may contain cheaper pigments and additives in place of pure pigments. These lower-quality pigments can result in paint that appears dull, or even chalky. I used artist grade paints for the projects in this book.

Don't feel pressured to start with artist grade paint. Many people start with student grade paints and then upgrade later. Starting out with student grade paint allows you to feel less constrained when practicing, as you're less worried about wasting expensive paint. I used student grade paint for many years while I painted as a hobby, and still do when *plein air* painting.

That being said, try not to go for the cheapest palette of paint available. The paints made for children tend to be quite chalky and will cause frustration for you in the long run. You can figure this out because usually those companies tend to label their colors without mentioning the pigment name.

Also, keep in mind that student grade paint is not lightfast and the colors may not blend very well. In addition, some student grade paints may start out as bright and vibrant as artist grade pigments, but will eventually fade over time.

CHARACTERISTICS

There are several characteristics of artist grade watercolor that you will encounter while selecting paint. This information can be found on the manufacturer's website or on the paint tubes themselves.

LIGHTFAST. Lightfast (or non-fugitive) paints are more permanent and will not fade as quickly over time. Non-lightfast (fugitive) paints are less permanent and will fade much more quickly with exposure to light.

TRANSPARENCY/OPACITY. Transparent paints allow light and the color of the underlying paper through, while opaque paints do not. Semi-transparent and semi-opaque paints are in between the two. As a whole, artist grade paint will be more transparent than student grade paint.

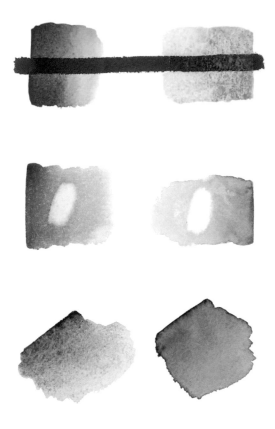

STAINING. Staining paints will soak into the page, making it difficult to lift/remove paint once it is applied. Non-staining paints can be lifted more readily off the page when rewetted. You might consider the staining quality of a particular color of paint when painting the sky. I like to put down a layer of paint first, and then lift off the color using a paper towel to create clouds. (More on this technique in Chapter 3.)

GRANULATING. Granulating paints have larger particles of pigments that will collect and can be seen on the surface of paper. Non-granulating paints have smaller pigments that more evenly disperse. Though it is up to personal preference, granulation can be used to your advantage to depict texture. The pigments that commonly granulate are Cobalts, Ultramarines, and earth tones such as Raw Sienna, Burnt Umber, and Burnt Sienna.

Notice the comparison of the paints above. The wash on the left is Green Apatite Genuine and the one on the right is Deep Sap Green. Notice how smooth and flat Deep Sap Green appears, while Green Apatite seems to have a texture.

DIFFERENT MODALITIES

Now that you understand the basic characteristics of watercolor, let's talk about the different forms watercolor comes in.

TUBE. These are metallic tubes containing concentrated amounts of a single color. Typically, you'll find individual colors sold separately, but you can also find sets of tubes as well.

PANS/HALF PANS. Pans and half pans are paint that are dehydrated before being sold. Pans are usually sold in a set of pre-designated colors. Alternatively, you can purchase empty pans and fill them with tube paint of your choice. The biggest draw for pans is that they are convenient for travel and *plein air* painting.

LIQUID. Liquid watercolor is concentrated and meant to be diluted prior to painting. I enjoy using liquid watercolors mostly for lettering, and not as much for painting, but that is a personal preference. Not all brands of liquid watercolor reconstitute well. In addition, liquid watercolors generally are not lightfast (excepting Dr. PH Martin's Hydrus) and paintings will lose vibrancy over time.

Watercolor characteristics vary between colors and manufacturers, even in high-quality artist paints! A color made by one manufacturer may appear darker or more vibrant than the same color made by another manufacturer. Therefore, many artists will have watercolors from different manufacturers in their palette. Don't feel that you have to stick to just one brand. Though the names of the colors may differ, you can find the corresponding color across major manufacturers by looking at the pigment numbers (usually found on the side of the tube).

ADDITIONAL ACCOUTREMENTS

Once you have your paper, brush, and paints, there are a few more things you need to get started.

- Water container to wet your brush and rinse off paint. Remember to never leave your paintbrushes soaking in water, as this can ruin your brushes.
- Palette to hold your paints. We'll discuss this more in the next chapter.
- Rag, paper towel, or sponge to wipe off excess water or paint.
- Pencil, to sketch out your composition before painting. Soft lead pencils erase more easily, but hard leads are more smudge-resistant and are less likely to appear under watercolor.
- Eraser(s)—I recommend rubber, kneaded, and sanding.
- Precision knife, for scraping or removing unwanted marks.
- Spray bottle, for reconstituting paints.
- Painter's tape.
- Patience!

ADVANCED SUPPLIES

These supplies are supplemental and can enhance your paintings. I consider these to be more advanced supplies to use after you get a good grasp on basic watercolor techniques, which you'll learn in Chapter 3.

MASKING FLUID/LIQUID FRISKET

Masking fluid is a tool used to block off areas that you don't want painted. When using masking fluid, be sure to use an old or inexpensive brush, as even one use will ruin brush hairs. Masking fluid dries fairly quickly and can be a bit difficult to use.

How to Use Masking Fluid

Materials: 140 lb. cold press watercolor paper, watercolor, brush, masking fluid and brush, soapy water

1. Submerge the brush head into a small container of soapy water. Swish it around a few times. Run your brush along the edge of the container to remove the excess liquid.

2. Dip your brush into the masking fluid. Apply the masking fluid to your paper. Rinse your brush in the soapy water in between strokes. Wash your brush completely after use.

3. Allow the masking fluid to dry completely prior to painting over it.

4. Allow your painting to dry completely before removing the masking fluid.

5. To remove, simply peel by hand, or gently remove with a sanding eraser.

6. Do not allow the masking fluid to stay on the paper for too long (overnight) as it may adhere.

TIP: Test the masking fluid on your paper prior to use. Some paper is more prone to tearing and not suitable for use with masking fluid.

INK

This is a great way to add detail or whimsy to a painting. A detailed ink illustration pairs beautifully with the loose style of painting you will learn in this book. If you choose to use a waterproof mono liner pen, such as a Sakura Pigma Micron or a Tombow Mono Drawing Pen, you can draw before painting without worrying about the pen bleeding. You can also use a brush pen or even a calligraphy pen and nib to add ink details to your paintings. The flexible tips allow you to vary the thickness of your lines. Many calligraphy nibs and pens are made for this purpose and therefore are waterproof.

GOUACHE

With gouache, unlike with watercolor, you can add light details over darker colors in a painting. After my watercolor paintings dry, I like to use gouache to add details, such as stamens to paintings of flowers or needles to paintings of cacti. If I'm only using a little amount of gouache, I simply squeeze the amount I need onto a well on my palette and mix with a few drops of water. If I know I'll be using a lot of gouache, I will mix the paint into a small airtight container with a lid. If the mixture thickens up, I simply add water, mix, and it is ready to use again.

Can you tell where I used gouache in this painting of Icelandic poppies? Gouache allows the yellow centers of these poppies to really pop against the brightly colored petals.

How to Prepare Your Paint

1. If you are using dry paint, lightly mist your paints with a spray bottle. Allow the paints to sit for a minute. This additional step before diving right into painting will allow the pigments to rehydrate and make them easier to dissolve.

2. Dip your brush in clean water. Remove the excess by lightly running the brush across the rim of your water container.

3. Charge, or load, the brush with a color of your choice. Mix the paint in a well on your palette by gently swirling your brush on the palette. If the paint seems too thick, add more water.

4. Continue adding paint or water until you achieve a consistency to your liking. The end result should be a puddle of paint about 2 inches in diameter.

As with watercolor, there are many supplies that can be used with lettering. There are many choices out there, but my list will stick to those I use and like the most, as well as those more specific to watercolor lettering.

The great thing about watercolor is that you really don't need that many supplies. And because you don't need a canvas or any other bulky materials, the medium is very freeing. You can take your work with you and paint whenever inspiration strikes! All you really need are paper, brushes, paint, and water.

Color

COLOR THEORY

Because colors affect the energy and overall feeling of a painting, it is valuable to understand the basics of color theory as it applies to watercolor.

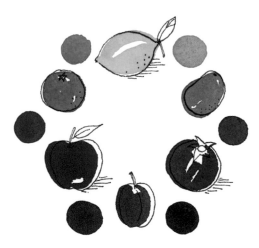

PRIMARY COLORS. Primary colors are those that cannot be mixed from a different color. There are three primary colors—red, yellow, and blue—that, in theory, make up all the other colors of the rainbow. I say *in theory* because depending on which red, which yellow, and which blue is used, the resulting colors will change. For example, a "true" red, such as Alizarin Crimson, mixed with a "true" blue, such as Prussian Blue, would result in a dark, muddy purple. However, choosing a red that is closer to magenta, such as Permanent Rose, and a blue that is closer to cyan, such as Cerulean Blue or Cobalt Blue, would result in a more vibrant purple. In other words, the colors you select as your base colors can change the resulting mixtures.

SECONDARY COLORS. Secondary colors result from mixing two primary colors. The three secondary colors are orange (red + yellow), green (yellow + blue), and purple (red + blue).

TERTIARY COLORS. Tertiary colors are those that are a result of mixing a primary color with a secondary color. There are six resulting colors: yellow-orange (amber), red-orange (vermilion), red-purple (magenta), blue-purple (violet), blue-green (teal), and yellow-green (chartreuse). Depending on the ratio

of secondary to primary color, one can expect a range of colors (quaternary and quinary), but we will stick to primary, secondary, and tertiary colors.

COLOR WHEEL

The color wheel appears in every beginner's art class, so it may look familiar to you. But there is not just one definitive color wheel.

I like to think of a color wheel as a tool to help you get more familiar with your paints. Depending on the paints chosen for the primary colors, you can end up with a very different palette. Notice the primary colors of the color wheel at the beginning of this chapter. They are the traditional red, yellow, and blue. The resulting secondary and tertiary colors are deep and bold. The purple is dark and muddy. Now, notice the two color wheels to the right. The primary colors are very different and result in a different palette. Keep this in mind when choosing the colors for your palette.

Color Wheel Exercise

In this exercise, we will be creating a color wheel. This is a great way to get comfortable with mixing paint to create new colors. If the primary colors you use differ from mine, you may have a different, but still correct, end result.

Paper: Arches 140 lb. Cold Press Watercolor Paper Paint: Winsor Yellow Deep (Hansa Yellow Deep), Permanent Rose, French Ultramarine

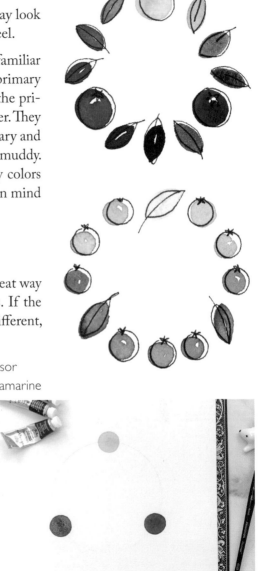

1. Using a pencil, lightly draw a circle in the center of your paper. Lightly mark off 12 lines along your circle. Try to keep them equidistant.

2. In three separate wells, mix your three primary colors with water. Refer to How to Prepare Your Paint on page 19 if needed.

3. Paint a swatch of yellow at the 12 o'clock position of the circle.

4. Paint a swatch of red at the 4 o'clock position of the circle.

5. Paint a swatch of blue at the 8 o'clock position of the circle.

6. In a new well, mix orange by mixing equal amounts of yellow and red. Paint a swatch of orange between your yellow and red swatches at the 2 o'clock position.

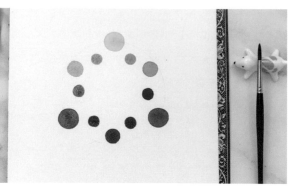

8. In a new well, mix equal amounts of yellow and orange to make yellow-orange. Repeat with red-orange, red-purple, blue-purple, blue-green, and yellow-green. See photo to reference the correct positions of the tertiary colors on the color wheel.

7. Repeat the previous step with green (yellow + blue) in the 10 o'clock position and purple (red + blue) in the 6 o'clock position.

COLOR VALUE

Value refers to the darkness or lightness of an object. If we lived in a world of black and white, it would be quite easy to determine the value of an object. A value of 0 would be white, a value of 10 would be black, and 1–9 would be increasing values of gray. However, we live in a world of color where it is difficult to determine the value of an object. Some colors, such as some blues and reds, have a wide value range. Other colors, such as yellow, do not have a wide range. The darkest yellow would probably never be darker than a 5 or a 6, and certainly never

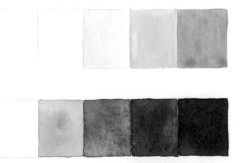

be as dark as the darkest blue. In this book, we are learning loose watercolor styles, so detail and value is not as important. For this style, you really just need to have a general idea of light, medium, and dark, and where to place those values in your painting.

Here is an example of why value is important. Look at these two very similar paintings—one where the entire painting has a very similar value, and another where the values are varied throughout the painting. The one with varying values is more interesting and grabs your attention. Vary the value throughout your paintings to draw interest to your piece!

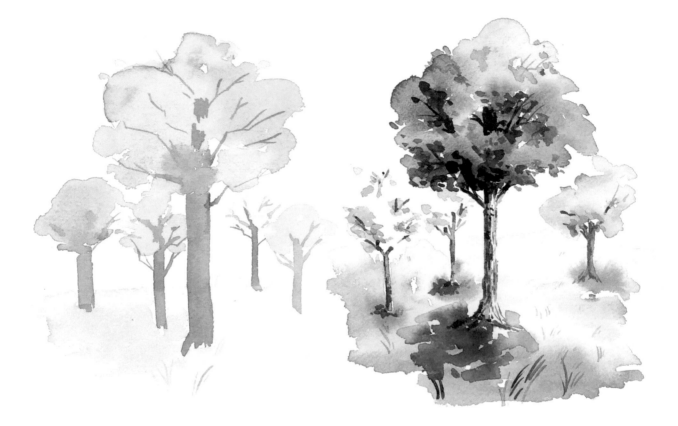

Value can also affect the overall feeling of a painting. Paintings done in all high-key (lighter) values feel softer and more ethereal than the drama and darkness that come with low-key (darker) values. The eyes tend to focus on areas that have more variation of value. So if you want the eyes to focus on the center, maybe paint with lighter values around the border of your paper and keep the darker colors in the center.

The last thing to consider when talking about color value is that watercolor always lightens when it dries. You may want to mix up a darker color knowing it will lighten once it dries.

Do not mix white with watercolor to decrease its value. This will result in an opaque pastel tint. And remember, transparency is one of the key qualities we like to preserve when painting with watercolor. It is okay to add black to increase the value of a color, but do so with caution, because most blacks have a warm or cool bias and a colored undertone. This means that when diluted or mixed with another color, it can result in an unexpected color.

COMPLEMENTARY COLORS AND COLOR HARMONY

Whether you have heard of the term *color harmony* or not, you experience it daily. When picking out clothes, you try to pick colors that "match." Color harmony is the idea that certain combinations of colors, when put together, are more appealing than others, or stand out more than others do.

On a day-to-day basis, I never sit and think, "Is this a triadic harmony? Is this a split complementary harmony?" But what I might think is, "What colors would look good against this lettering?" or "What additional color can I add to this painting but still keep it cohesive?" So while it isn't important to remember the technical terms, it is important to have a good understanding of the color combinations that are harmonious and those that are not.

COMPLEMENTARY COLORS: Also known as colors in direct harmony, complementary colors are directly across from each other on the color wheel. (Red—Green, Yellow—Violet, Blue—Orange). In watercolor, adding a small amount of a complement can tone down a bright color. And when two complements are mixed together in equal amounts, they tone each other down to form gray.

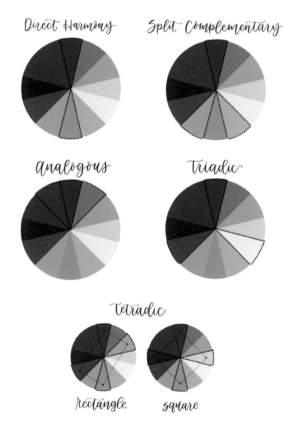

When put together in a painting, complementary colors create an aesthetically pleasing combination. Because they are "opposite" colors, they can fight for attention. If using direct harmony, it's wise to let one color be the center of attention (key color), while using the other color sparingly.

SPLIT COMPLEMENTARY: Split complementary colors are those that are directly to the right and left of the complementary color.

ANALOGOUS COLORS: Analogous colors are those that are directly to the right and the left of the key color on the color wheel.

TRIADIC: Triadic colors are those that are spaced equidistant from each other on the color wheel (or two colors away from the complement).

TETRADIC: A tetradic color scheme is one that contains two pairs of complementary colors. Because you end up with four colors, you want to pick one as your key color and use the other three as accents. The two tetradic color schemes are rectangle and square (each of the four colors are equidistant from each other).

There are many other color schemes and much more to color theory than what is presented in this book. But this is a great foundation and more than enough to know as a beginner.

If you find yourself having a hard time choosing paint colors and would like to try out colors prior to purchasing, some companies provide dot cards for purchase. They are cards with small amounts of watercolor paint that can be used to test colors, or to paint.

A BASIC PALETTE MIGHT CONTAIN:

- Cool Yellow (Hansa Yellow Light or Lemon Yellow)
- Warm Yellow (Cadmium Yellow Deep or New Gamboge)
- Warm Red (Cadmium Red or Scarlet Lake)
- Cool Red (Permanent Alizarin Crimson or Pyrrol Crimson)
- Pink (Permanent Rose or Rose Madder Genuine)
- Warm Blue (Ultramarine Blue or Cobalt Blue)
- Cool Blue (Cerulean or Phthalo Blue)
- Cool Green (Phthalo Green [Blue Shade] or Viridian)
- Warm Green (Permanent Sap Green or Green Apatite Genuine)
- Earth Tones (Burnt Umber, Burnt Sienna, Yellow Ochre, Brown Ochre)
- Some convenience colors I like to use:
- Blue: Indigo
- Green: Olive Green, Hooker's Green
- Pink: Opera Rose
- Violet: Violet Dioxazine, Ultramarine Violet
- Gray: Payne's Gray
- Earth Tones: Sepia
- Black: Ivory Black

These are the colors I use most often for the type of painting I do, all by Winsor and Newton Professional: Lemon Yellow, Yellow Deep, Scarlet Lake, Alizarin Crimson, Permanent Rose, Opera Rose, Ultramarine Violet, French Ultramarine, Winsor Blue (Green Shade), Winsor Green (Blue Shade), Permanent Sap Green, Yellow Ochre, Burnt Umber, Payne's Gray.

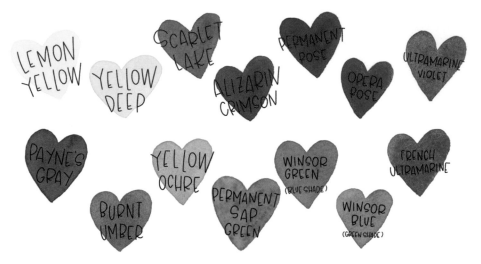

What about white? As you recall, translucency is one of the most important characteristics of watercolor. The addition of white causes watercolor to become opaque, similar to gouache. Most artists use the white of the paper when white is needed. You would rarely use white in watercolor, except maybe to overlay details at the end of a painting, as in splatters or flecks of snow on a tree, or stars in the sky.

ARRANGING YOUR PALETTE

If you are using tube paint, you will need a palette. I recommend getting a plastic folding palette or one with a lid. Prep your palette by washing it with a mild abrasive, such as the back of a sponge, before filling it with paint. This additional step gets rid of any manufacturing residue, allows the paint to stick to the palette, and prevents beading. After prepping, fill each well with paint. I like to leave a small space in each well to allow for mixing with water, but other artists like to fill up the entire well. Whatever you decide, allow the paint to dry overnight. Shrinkage of the paint while drying is completely normal, with some brands of paint shrinking more than others.

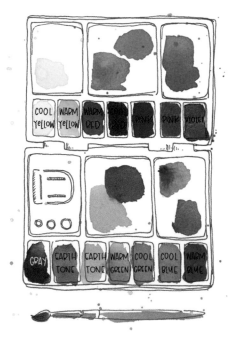

Basic Watercolor Techniques

In this chapter you will learn fundamental watercolor painting techniques. You'll start with basic techniques and then move on to different types of washes. Next, you'll get familiar with mixing and diluting colors to create a few different color charts. Finally, you'll end with one of my favorite parts of watercolor: adding texture to your paintings. For all of these exercises. I recommend using a round size 6 brush and 140 lb. cold press watercolor paper. You can use the color of your choice, though I may suggest a certain color for specific techniques. Before learning the essential techniques for watercolor painting, it's important to learn how to make marks with your watercolor brush.

MARK-MAKING EXERCISES

Mark making is simply that—making marks with any art media, such as watercolor, on any art surface, such as paper. Anything from a splatter of paint to a crosshatched pattern can be considered a mark. Different marks create different textures, convey different emotions, and can even become distinct and attributed to a specific artist. Consider the famous artists Georges Seurat, Vincent Van Gogh, and Jackson Pollock. These artists are known for their distinct marks—pointillism, swirled brush strokes, and splatter, respectively.

The purpose of the following exercises is not to copy the examples exactly, but to get familiar with holding a watercolor brush and testing its capabilities. This is the perfect way to figure out how much water/paint you prefer on your brush, how much pressure you need to create a type of stroke, and what angle you need to hold your brush to create different marks. These are also great exercises to do before painting to loosen up. Practice this exercise, but afterward, see what other marks you can create on your own.

We will cover paint and color later, so for now, choose your favorite color to complete this exercise. As you go through the rest of the book, you'll notice that you'll be using the marks you learn in these next few exercises. If you are an absolute beginner, it may be a good idea to finish reading the rest of this section first.

As with all exercises in this book, I will list the supplies I used. It is not important to have the exact same materials, but anything close to it will work. Unless otherwise stated in the exercise, I am using:

Paint: Winsor and Newton Professional and Daniel Smith Watercolors

Paper: Arches Art 140 lb. Cold Press

Brush: Princeton Heritage round 6

Water and Paint

Using a flat brush (Princeton Velvetouch Flat), create different marks by varying the amount of water and paint on your brush. Notice that a relatively dry brush results in interesting textured lines, while a fully loaded brush creates broad, flat strokes. The more water you use, the lighter your paint will be. The less water you use, the darker the paint will be.

Thickness and Pressure

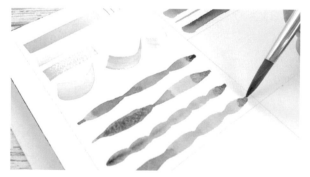

1. Using a round brush, create thin lines by using light pressure and a more upright angle. Create thicker lines by increasing pressure and reducing the angle between the brush handle and the paper.

2. Continuing with a round brush, try creating swells. To do this, start with light pressure at the tip of your brush. As you move your brush in a horizontal direction, increase pressure to the belly of the brush. Gradually release pressure to create a fine tip. If you find this to be challenging, try it at a slower speed.

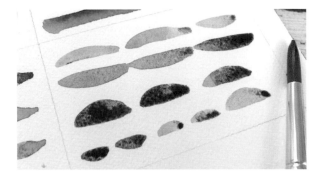

3. Now try painting swells with a straight bottom by applying pressure only in the direction you want to create the swell. To create a shape that looks like a hill, add pressure toward the top of your paper. To create a shape that looks more like a boat, add pressure toward the bottom of your paper. Don't worry if you don't get it right away. Putting the "hill" and the "boat" together is how I paint a basic leaf.

Angles

Vary the angle of your round brush while lightly tapping on the paper. Notice that an upright 90-degree angle creates dots while a flatter angle creates a more oblong shape. Repeat this exercise with a flat brush. Notice that an upright brush will create small lines.

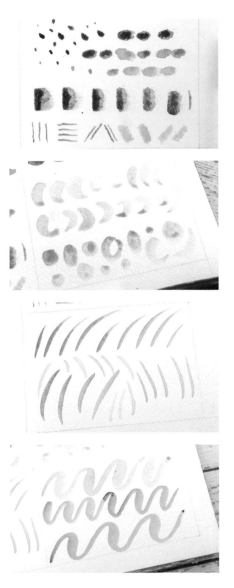

Movement

Create curves by moving your round brush in a "C" pattern. Practice flatter and more tightly curved "Cs". Then, move your brush in a small O pattern to create circles and ovals.

Speed

Use light pressure and quick upward and downward movements to make marks like those shown here. As your brush leaves the page, the lines become thinner and may leave a slight texture.

Calligraphy Strokes

Paint a line of waves by creating a series of thick and thin lines while moving in an up-and-down, serpentine pattern. Notice that upstrokes create thin lines while downstrokes create thicker lines. This is a technique that will be further explored in the second half of this book.

BASIC TECHNIQUES

Wet on Dry

This technique uses wet paint on dry paper. It produces crisp, hard edges. Because the paper is dry, it is easy to control where the paint goes. Explore this technique by using varying amounts of paint and water.

1. Charge (fill brush with paint) your brush with your color of choice.

2. Apply paint to a dry area of paper.

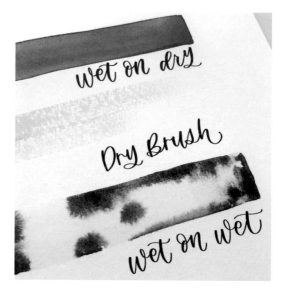

Dry Brush

Watercolor paint needs water to move across a page. Minimal water is used in this technique to create textures. To achieve a dry brush technique, apply wet paint to a dry paintbrush.

1. Charge your brush with a color of your choice.

2. Remove excess moisture from the brush by dabbing on a clean towel or sponge.

3. Apply paint to a dry area of paper.

Wet on Wet

This technique uses wet paint on wet paper. Lightly dampen your paper, add paint, and watch as the paint moves. It's unpredictable where the paint will bloom, and quite fun to watch! This technique will result in soft, almost blended edges.

1. Apply clean water to an area on your paper. It should be enough water that it leaves a nice sheen, but not so much that it leaves a pool of water.

2. Charge your brush with your color of choice.

3. Dab the brush into the damp area of your paper.

VARIATION: Instead of using clean water, try using a light wash of the color of your choice.

GLAZING

Glazing is a technique used to add depth to a painting by taking advantage of the transparent qualities of watercolor. To achieve this technique, allow the first layer of your paint to dry completely. (Be patient!)

When you are certain it is dry, add another layer of paint. The resulting effect can be likened to stacking colored lenses.

Raindrops

Practice glazing by painting raindrops inside of a circle. The colors you choose are not important. The main focus of this exercise is to get familiar with how long it takes for paint to dry in order to glaze over it, and to get familiar with transparency of watercolor.

Paint: WN Opera Rose, Permanent Rose, Scarlet Lake, and Yellow Deep. Gold from Coliro Colors Finetec Gold Palette

1. Using a pencil, lightly sketch a circle on your paper.

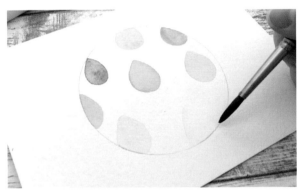

2. Using the colors of your choice, paint several large raindrops throughout the circle. Allow the raindrops to dry completely. Once dry, the paper should appear matte.

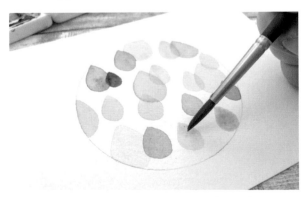

3. Paint several more medium-sized raindrops throughout the circle, this time allowing the drops to overlap. Allow the paint to dry completely.

4. Paint small-sized raindrops throughout the circle. Allow the drops to overlap the larger raindrops.

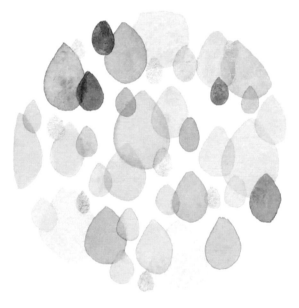

5. Optionally, add small raindrops of gold throughout the painting.

SCUMBLING

Scumbling is a watercolor technique that adds depth and texture to painting. Always keep in mind the transparent nature of watercolor, and use a lighter color on the bottom layer and darker colors on top. If done in reverse, the lighter colors will not show up over the darker colors unless they are opaque.

Tree

Paint: WN Permanent Rose and Scarlet Lake

1. Wet a small circular area of your paper using clean water. Allow it to dry to a light sheen. Meanwhile, mix a puddle of Permanent Rose and Scarlet Lake.

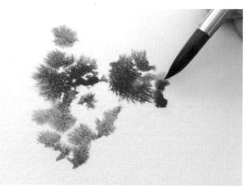

2. When the water is only slightly damp, use a wet-on-wet technique to drop in the Permanent Rose and Scarlet Lake mixture. Allow paint to dry completely.

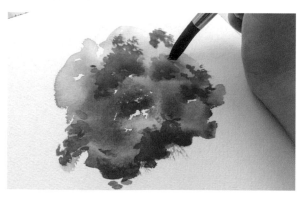

3. Once you are certain the area is dry, recharge your brush and haphazardly add a second layer of paint by scribbling with your brush. I like to use quick up-and-down taps and side-to-side motions.

4. Allow the previous layer to dry and continue to add additional layers until you are satisfied with the look.

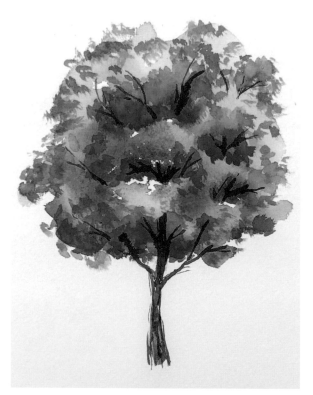

5. Use a mixture of an earth tone like Burnt Umber and a blue like Payne's Gray to create a neutral brown. Charge your brush and paint in a trunk and branches. Congratulations, you just painted your first tree!

WASHES

Washes are generally used to cover a large portion of paper.

Flat Wash

This is one of the most difficult washes. When done correctly, you end up with even coverage of one color over the area you are painting.

1. Charge a round brush with the color of your choice and paint a thick strip at the top of your paper.

2. Tilt the top of the paper, allowing gravity to bring excess water (a bead) to the bottom corner of the strip you painted in step 1.

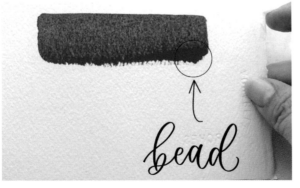

bead

3. Using your brush, pick up the bead at the bottom and move it down the page using side-to-side motions.

4. Continue steps 2 and 3 until you've created a flat wash.

5. Dab your brush on a clean paper towel or cloth to remove excess water. Should a bead still remain at the bottom of your wash, use the tip of your brush to gently soak up the bead. Take care not to touch your paper or to remove too much paint, as this will create a lifting effect and leave you with an uneven wash.

TIP: If you lay the paper flat prior to picking up the bead, this will cause the paint to flow back into the wash (back run) and result in an uneven wash.

Graded Wash 1

The result of this wash is much like an ombré—concentrated pigment that is gradually diluted. There are a few ways to achieve this wash.

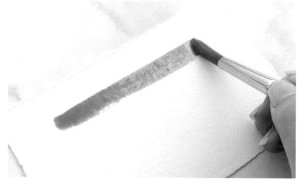

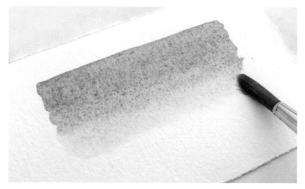

1. Paint a thick strip at the top of your paper.

2. Dilute the paint on your paintbrush. Don't swirl the brush in the water; simply dip then remove excess water by lightly running the brush across the lip of your water jar.

3. Touch the brush to the bottom edge of the strip of paint and slowly move your brush side-to-side and downward.

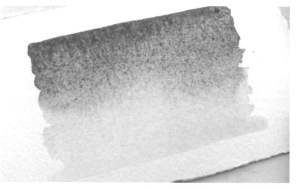

4. Repeat steps 3 and 4 until your brush is completely free of paint and you have a graded wash.

Variegated Wash

Watercolor is unique in that paints can be mixed directly on the paper. In this wash, each of the colors will remain distinct on opposite ends, but gradually bloom and blend in the middle, creating a third color. Another term for this is charging.

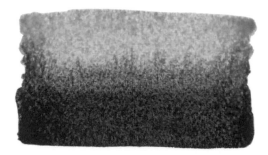

The direction a bloom will move in can be unpredictable, and trying to control blooms can be frustrating. If you embrace this feature of watercolor, you may be pleasantly surprised!

1. Paint a wash of color on one side of your paper.

2. Completely rinse off your brush and pick a new color. At the opposite side of the paper, paint a second wash with the new color, allowing the two colors to touch. You will notice a bloom of color as the two colors blend into each other.

3. You may further blend the colors into each other using a gentle side-to-side motion with your brush. This will create a gradual blend.

TEXTURES

We explored creating a few textures in the mark-making exercise, such as the texture of a dry brush. Here are additional ways to create textures on your paintings. Even if you're not planning to incorporate these techniques into your paintings, you really should give them a try. Adding ingredients is my favorite!

ADDING INGREDIENTS

Introducing different materials to your painting will result in different textures. Commonly used materials are water, alcohol, bleach, and salt. Note that any of these additives can affect the archival quality of your painting.

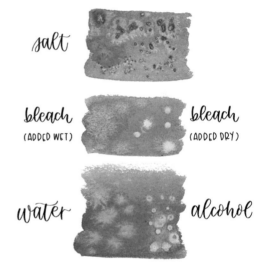

WATER. Paint a flat wash onto your paper. While it's still slightly damp, add a drop of water. Watch how the colors disperse and leave behind a diluted spot.

ALCOHOL. Wet a cotton swab with regular rubbing/isopropyl alcohol and bring it close to a damp wash without touching the paper. The alcohol will repel the water and reveal the white of the paper below.

BLEACH. Bleach will remove the color from your painting and reveal the white of the paper underneath. However, too much bleach can eventually eat away at your paper, so you might choose to dilute it or use it very sparingly.

SALT. Add a few grains of salt while a painting is still damp The salt crystals absorb the water and leave behind interesting stellate patterns.

ADDING SOAP

This is a great way to add texture to your paintings, but also just a fun activity in general (especially with kids!). I like to use this method to create a beachy looking wash and letter over it.

Painting with Soap

Materials: 140 lb. cold press watercolor paper, watercolor (liquid is easiest, but any will work), straw, soapy water in a shallow container

1. Start by adding liquid watercolor to the soapy water mixture until you get a color you're happy with. You may need to add about a teaspoon or more to create a dark color.

2. Using a straw, blow bubbles into the mixture. You'll want to blow a lot of bubbles. They should reach past the height of the container they are in.

3. Quickly flip your paper upside down over the bubbles, and touch the bubbles so they pop onto the paper.

The finished product is beautiful to frame as is, but I like to use it as a background for my lettering.

LIFTING

You can create textures in your washes by lifting paint after it has been applied. You can remove the paint while it is still damp. Lifting after it has dried with a damp brush will create different effects—usually harder edges. Lifting with differently textured objects will result in interesting shapes and textures. Recall that some colors will lift better than others due to their staining qualities.

Creating Clouds

Materials: 140 lb. cold press watercolor paper, watercolor, brush, paper towel

1. Paint a graded wash using the blue of your choice.

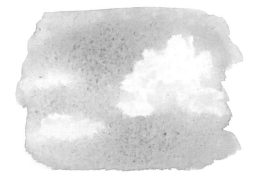

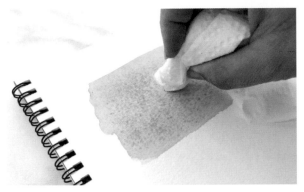

2. Working quickly while the paint still gives off a light sheen but not pooling, lightly dab the paint with a clean, dry paper towel. Rotate the paper towel in between lifts to produce new shapes.

SPLATTER

Splatter is a fun and unpredictable technique. To do this technique, charge your paintbrush with some paint and tap it against a hard edge (such as the handle of another paintbrush) over your paper. Another method is to use a brush with stiff bristles or a toothbrush, and run your finger against the bristles.

SCRAPING

Scraping results in a wide variety of textures depending on the tool used, and how wet the painting is. It can be done using a palette knife, a scraping tool, the tip of a paintbrush handle, the tip of a precision knife, or even just an old credit card. The technique is as easy as it sounds: Simply take your tool and scrape it against your paper. Scraping when wet will create an indentation in your paper that will pool and result in a dark line. Scraping when damp will push the paint aside to reveal the white paper underneath.

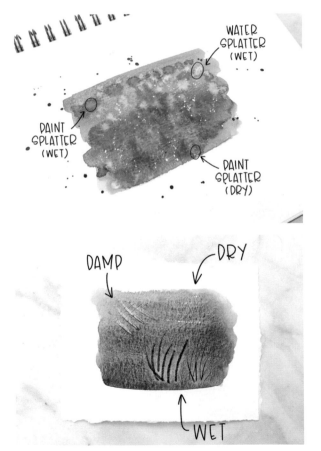

Painting

Every single painting in this chapter is in the loose watercolor style and applies the techniques you've learned so far in this book. You'll be using these loose painting designs in the projects in Chapter 11. A loose painting style means you will not be attempting to capture every detail, but rather focusing on the subject's basic shape, color, and movement. Each painting will be taught step-by-step.

When practicing these exercises, don't spend too much time trying to get something "just right." When I paint in this loose style, I paint fairly quickly and avoid using too many strokes. The result is a painting that is modern and light. For further practice beyond this book, I recommend using a reference photo. To keep things light, minimize the size of the photo to eliminate all the details. I keep my reference photos at a small size so that just the colors, values, and basic shapes are prominent. Otherwise, it's easy to get stuck on the details, resulting in an overworked painting.

While following along these exercises, if you don't end up with the same result, don't fret. Just keep in mind what worked for you and what you could change for next time. These exercises are just guides, so make them your own. The key is to just keep painting, keep practicing, make some progress, and have fun!

Unless otherwise stated, I am painting on Arches Art 140 lb. Cold Press watercolor paper.

Ocean-Themed Wash

You will use broad strokes and implement wet-on-dry and variegated wash techniques to create a loose, ocean-themed wash. This type of wash is a perfect background to letter over.

Paint: WN Manganese Blue Hue, DS Cobalt Teal Blue, WN Winsor Green (blue shade), WN Brown Ochre, WN Yellow Ochre, WN Ivory Black Brush: PH Round 14, PH Round 1

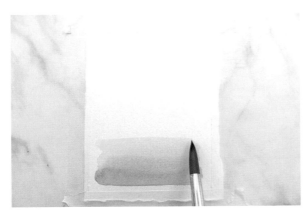

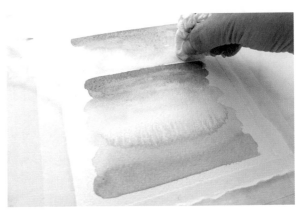

1. Mix Brown Ochre and Yellow Ochre to make a nice sand color. Load your brush and, starting at the bottom third of your paper, apply the paint, moving upward in horizontal back-and-forth motions to create a subtle gradient.

2. Rinse off your brush. Leave a little light space denoting bubbles and froth where the water meets the sand. Charge your brush with Cobalt Teal Blue and begin painting the ocean with the same back-and-forth motion, moving upward.

3. Mix a bit of Winsor Green with Cobalt Teal Blue. Dab areas of the ocean with this color to denote areas of shadow.

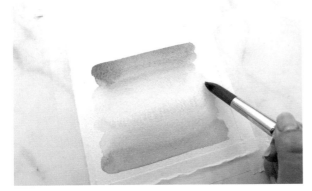

4. Rinse off your brush and load with Manganese Blue Hue for the sky. Create a gradient from the top down using side-to-side motions.

5. Use a clean paper towel to gently lift areas of the sky to create clouds.

6. While the ocean area is still wet, use the darker mixture of Winsor Green and Cobalt Teal Blue to paint a thin line where the water meets the sky, denoting the horizon.

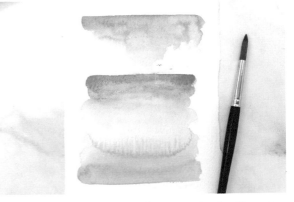

7. Allow the painting to dry completely. Once it is dry, use the thin brush (round 1) to paint upside down wide "W"s to denote birds in the horizon.

Galaxy

For this exercise, you will paint a galaxy using a wet-on-wet technique. The stars are added using splatter and opaque paint. I used white for the stars in this painting, but you could also use gold or metallic paint. Closer stars are depicted using larger splatter from a paintbrush, while stars that are farther away are splattered smaller using a toothbrush.

If you choose to forego painting in a shape and would rather paint the whole paper, then tape down the edges of your paper with painter's tape to leave a clean edge.

Though I've listed the colors I used, galaxy paintings really look great in any color. Recall our discussion on color harmonies and be sure to pick colors that look nice together.

Paint: Royal Talens Ecoline Liquid Watercolor 700 (Black), 337 (Magenta), 505 (Ultramarine Light), 548 (Blue Violet) Brush: PH Round 16, Round 10 Additional Materials: Dr. PH Martin's Bleed Proof White (BPW), Toothbrush

1. If painting within a shape, lightly sketch the shape on regular printer paper. Cut out the shape on the printer paper so that what you have left is a stencil, or negative space. For example, if your shape is a circle, you should have a hole in the middle of your paper. Use the stencil to trace the shape onto your watercolor paper. Save the stencil for later.

2. Charge your brush with clean water. Wet your paper enough that you see it glisten when you look at your paper at an angle, but not so wet that there is a visible puddle of water sitting at the surface.

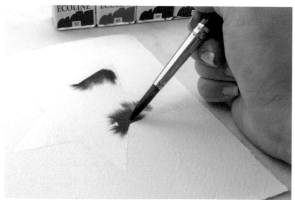

3. Next, charge your brush with 337 and dab the wet areas of your paper. Take care to leave a white area on the center of the paper. This white area will depict a nebula or faraway galaxy.

4. Repeat step 3 using 505 and 548.

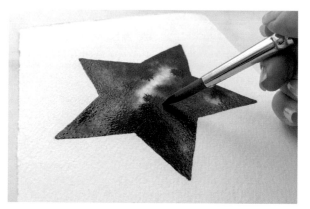

5. Charge your brush with black (700) and dab at the edges of your painting. You may have to repeat this step a few times to get a dark color.

6. Let the painting dry completely.

7. If you've painted within a shape, place the stencil that you cut out earlier over your paper. The stencil should cover the white part of your paper, leaving only the galaxy visible.

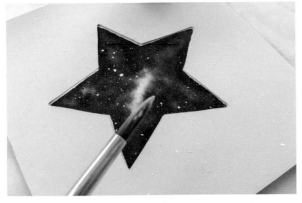

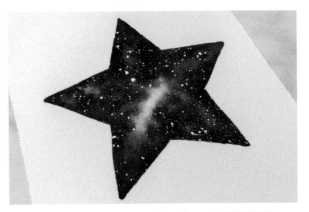

8. Once you are sure that the painting is dry, use a toothbrush and opaque white paint to splatter stars onto the first layer.

9. Charge your round 10 brush with BPW. Tap on the brush to splatter larger stars onto your painting.

Pink Snowberries

Unlike winterberries, I like to paint snowberries in clusters. If you examine a branch of berries closely, you can see that some are whiter, some are a deep pink, and others are transitioning from white to pink or even green to pink. To depict this, use wet-on-wet methods and I allow the edges of the berries to touch, resulting in beautiful blooms of paint. When using Permanent Rose at full strength, it results in a deep, dark pink. When diluted, it results in a delicate and soft pink—the perfect color for these berries.

Paint: WN Winsor Lemon, WN Permanent Rose, WN Hooker's Green, WN Raw Umber, WN Payne's Gray **Brush:** PH Round 6

2. In a separate well, mix Winsor Lemon and Hooker's Green. Dilute the mixture by adding water. It should be quite pale.

3. Charge your brush and paint a new cluster of berries using the green mixture. Allow the edges to touch.

1. Dilute some Permanent Rose with water and charge your brush. Paint a small cluster of berries, allowing the edges to touch very slightly. Add a little more Permanent Rose to your diluted mixture to increase the value of the color, then lightly dab the outside edges of two of the berries, allowing the color to bloom.

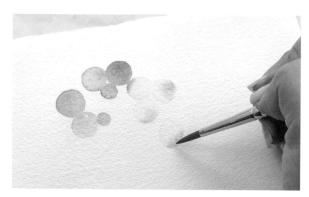

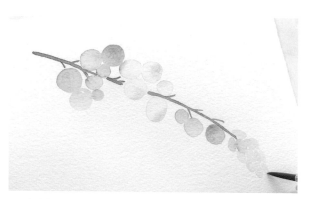

4. Rinse your brush completely to avoid mud and lightly dab it on a clean paper towel to remove excess moisture. Charge your brush with the pink mixture. Then, dab the outside edges of the green berries and allow the colors to bloom.

5. In a new well, mix Raw Umber with Payne's Gray to produce a dark brown color. Charge your brush with this color.

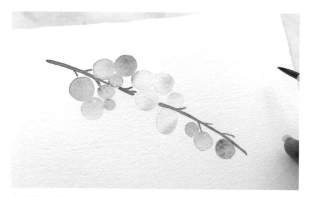

6. Use the tip of your brush to paint a branch that connects the berry clusters. In the same manner, paint a few stems coming off of the branch that lead to the berries.

7. Add a small amount of Hooker's Green to the green mixture. Charge your brush, then paint a cluster of small, oblong green berries at the end of the branch.

8. Mix Payne's Gray with Hooker's Green to produce a deep, dark green. Charge your brush with this dark green mixture

9. Use the two-stroke method to paint the leaves: use two adapted swells with the flat parts facing each other. In some of the leaves, leave a sliver of space between the two strokes to denote the midrib of the leaf. (Refer to the mark-making exercise on page 28.)

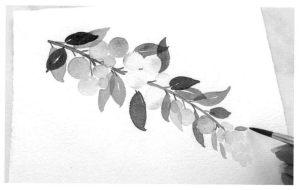

10. As you paint additional leaves, change the value by varying the amounts of water you use with the previous green mixture. Optionally, add more leaves using a glazing technique to indicate a fuller branch. If including this step, be sure the first layer is dry to minimize bleed.

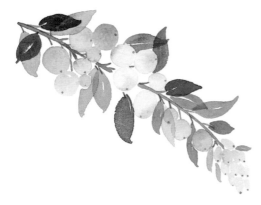

11. Once the paint is dry, use the dark brown mixture to add stems to the leaves and details on the ends of the berries.

WINTERBERRIES (ILEX)

Use Scarlet Lake, Brown Ochre, and Payne's Gray to create bright clusters of berries against neutral-colored branches.

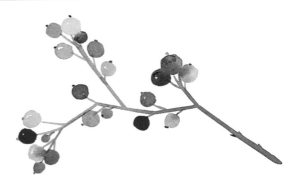

Olive Branch

If you don't have the Olive Green recommended for this exercise, you can mix a similar color using Permanent Sap Green and Yellow Ochre. For black olives, you can mix your own olive-y black by adding in a bit of Sepia to give it a warmer color, and then Payne's Gray to darken the color. If you don't have Sepia, you can substitute it with one of your darker earth tones.

Paint: WN Permanent Sap Green, WN Olive Green, WN Yellow Ochre, DS Sepia, WN Payne's Gray, WN Ivory Black Brush: PH Round 10

1. Mix a small amount of Payne's Gray with Yellow Ochre to tone down the yellowness of the color. Load your paintbrush with the mixture.

2. Using the tip of your brush at an upright angle, paint a graceful, slightly s-shaped curve. Lift your brush once or twice to leave spaces for the olives. Use decreasing amounts of pressure as you reach the tip of the branch.

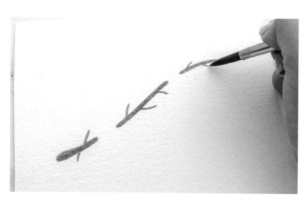

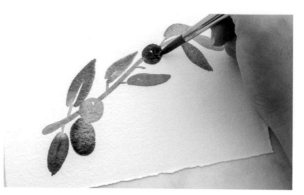

3. Reload your paintbrush if necessary, and use the very tip of the brush to paint stems coming off of the branch.

5. Using Olive Green, paint in oval shapes to represent olives from a side view, and circular shapes to represent those from a more top/bottom view.

6. Using the black mixture, paint another olive. Leave a white space to suggest light reflecting off of the olive.

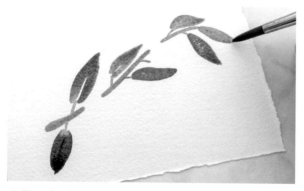

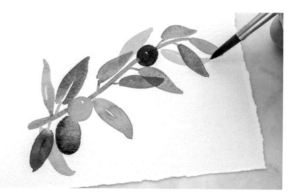

4. For the leaves, mix a puddle of Permanent Sap Green and paint using the two-stroke method (see step 10 of Pink Snowberries on page 42.) For darker leaves, mix a small amount of Payne's Gray with Permanent Sap Green. For lighter leaves, use Permanent Sap Green at a lighter value.

7. Optionally, add more leaves using a glazing technique to indicate a fuller branch. If including this step, be sure the first layer is dry to minimize bleed.

Rosemary

Rosemary is recognizable by its woody stems and skinny leaves. Its blooms can be white, pink, blue, and purple. Here, you will use Ultramarine Violet, a beautiful cool violet. When painting the individual leaves of the rosemary, be sure to vary the values and angles of some of the leaves for a more natural look.

Paint: WN Ultramarine Violet, WN Permanent Sap Green, WN Yellow Ochre, WN Brown Ochre, WN Payne's Gray **Brush:** PH Round 6

1. Mix Permanent Sap Green and Yellow Ochre to produce a warm green. Charge your brush with this mixture.

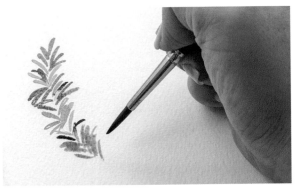

2. Paint in short upward strokes for the leaves of the rosemary. Use the area between the tip and the belly of your brush. The leaves should be painted in somewhat of a v-pattern.

3. Continue adding leaves using varying ratios of Permanent Sap Green, Yellow Ochre, and water. Leave spaces between the clusters of leaves to add the stems and flowers.

4. Add a bit of Payne's Gray to your green mixture and add darker values to the rosemary. Allow the paint to dry slightly.

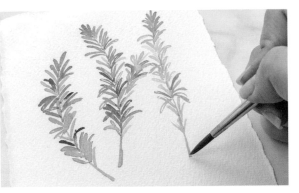

5. Mix a puddle of Brown Ochre. Add the stems of the rosemary wherever you have spaces between the clusters of leaves. If you prefer no bleeding at all, allow the leaves to dry completely before this step.

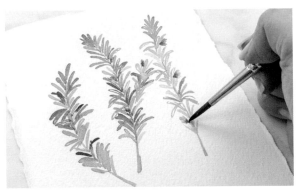

6. Add small clusters of flowers along the rosemary using Ultramarine Violet.

Poppies

Poppies are always a treat to paint because the various colors just look so beautiful and happy together. After the petals are painted, the details of these flowers are added using a mixture of yellow and white gouache. The addition of the details really transforms the painting.

Paint: WN Lemon Yellow, WN Yellow Deep, WN Winsor Orange, WN Scarlet Lake, WN Permanent Rose, WN Hooker's Green, WN Yellow Ochre Brush: PH Round 10 and 2 Other: WN Designer's Gouache Permanent Yellow, Permanent White

1. Charge your round 10 brush with a mixture of Winsor Orange and water. Using slightly curved, broad strokes, begin to paint the petals starting from the outside toward the center.

2. Dip your brush in water but do not completely rinse off the paint. Paint more petals at this lighter value to depict light hitting the petals.

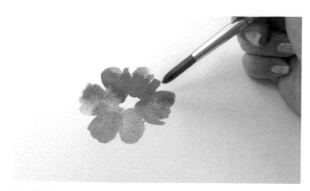

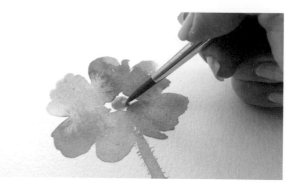

3. Add a small amount of Yellow Deep to your Winsor Orange mixture and paint another petal. Notice that the addition of a new color creates interest in the overall look of the painting. Use a lighter value of Winsor Orange to finish the petals.

4. While the petals are drying, mix Hooker's Green with Yellow Ochre. Using even pressure, paint a stem coming from the flower without allowing the stem to taper.

6. Once the petals are fully dry. Mix Hooker's Green with a small amount of Lemon Yellow. Use the size 10 brush to paint a small green circle at the very center of the flower. Allow to dry completely.

7. Load the size 2 brush with a mixture of yellow and white gouache. Paint a stellate shape on the previously painted green circle.

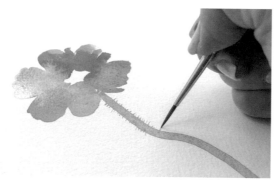

5. Switch to a size 2 brush and charge with the green mixture. Paint very fine hairs coming from the stem using the tip of the brush.

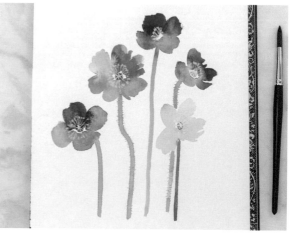

8. Continuing with the size 2 brush, paint stamen coming radially off of the green circle. For the filaments, use the tip of your brush to paint very thin lines. For the anther at the end of the filament, press down gently at the tip of your brush.

Rose

I have always had difficulty painting roses in a loose style. It is so easy to get stuck on all the details of the layers of petals. Roses are painted with thinner tapered strokes. As you move from the inner to the outer

petals, the strokes get thicker and lighter in value. To create these petal shapes, you will be combining a c-shaped curve with a swell. In other words, the tips of your C should be thick and the curve should be thin.

Paint: WN Yellow Deep, WN Scarlet Lake, WN Permanent Rose, WN Opera Rose, WN Hooker's Green Brush: PH Round 6 Paper: Legion Stonehenge Aqua 140 lb. Cold Press

1. To a base of Permanent Rose, add a small amount of Scarlet Lake and Opera Rose and just a touch of Yellow Deep to create a salmon color. Charge your brush.

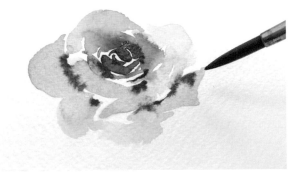

2. Use the tip of your brush to paint the inner petals of the rose. I like to start with two interlocking C shapes, a capital G shape, or the shape of a comma.

4. Dip your brush in water to lighten the value of the color and add thicker petals all around the center of the flower. Add darker values to the bottoms of the petals using a wet-on-wet method.

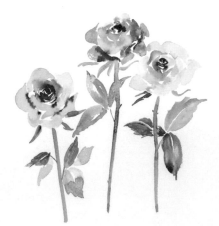

3. Add the next row of petals.

5. Charge your brush with a mixture of Hooker's Green and Yellow Deep to add a stem and leaves to your flower.

TIP: For a head-on, top view of the rose, paint equal amounts of petals all around the center. For a more side view, paint more petals to one side and less on the other.

Peony

For my wedding bouquet, I had beautiful, elegant, giant blush pink peonies that were just barely beginning to bloom. Since then, peonies have always been special to me and painting them is also a treat. Recall the mark-making exercise where we painted various c-shaped curves. You will utilize these curves to paint the petals of the flower. Once the petals are completely dry, you will use gouache to add in the details of the stamen.

Paint: WN Winsor Yellow Deep, WN Scarlet Lake, WN Permanent Rose, WN Hooker's Green, WN Payne's Gray Brush: PH Round 10 and 2 Additional Materials: WN Designer's Gouache Permanent Yellow, Permanent White, Lemon Yellow

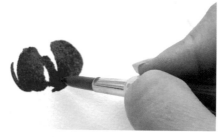

1. Load your size 10 brush with a mixture of Permanent Rose and Scarlet Lake. Paint the inner petals using a dark value and short c-shaped curves.

2. Decrease the value by dipping your brush in water and removing the excess on the rim of the water container. Continue to add more petals using curved brush strokes.

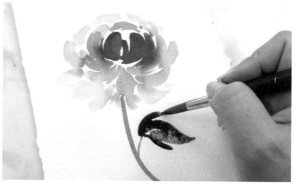

5. Charge your size 10 brush with a mixture of Hooker's Green and Payne's Gray. Add a stem and leaves to your peony. Allow to dry completely.

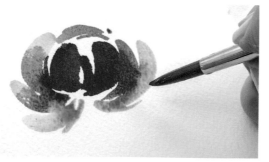

3. Pick up a small amount of Yellow Deep and add a few more petals.

4. Switch back to the Permanent Rose/Scarlet Lake mixture and finish off the flower. If you'd like, add darker values using a wet-on-wet method.

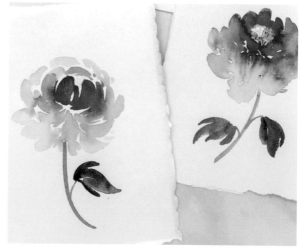

6. Once dry, use your size 2 brush and a mixture of the three colors of gouache to add stamen to the center of the peony.

Strawberry

Strawberries are always fun to paint. The details of the seeds can be added using a darker paint color, a micron pen, or even a lighter yellow color of gouache. You can even use a white ink pen or white gouache to add highlights around each seed to give it a different look. I've painted a few strawberries here so you can decide for yourself which method you prefer.

Paint: DS Permanent Red Deep, WN Winsor Yellow Deep, WN Hooker's Green, WN Burnt Umber
Brush: PH Round 6 and 2 Additional Materials: Pigma Micron, Gouache (WN Yellow Deep + WN Permanent White), White Gelly Roll

1. Using clean water, paint out the shape of a strawberry. It is similar to a heart but rounded on both top and bottom.

2. When the water is no longer a puddle but a nice sheen, use the wet-on-wet method to add Permanent Red Deep to the bottom of the strawberry and Yellow Deep to the top. If you will be painting more strawberries, you can allow the berries to touch and bleed. I also like to paint them in varying values to have some stand out, and others recede.

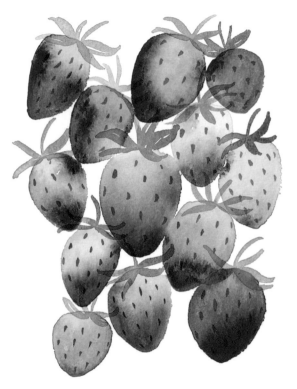

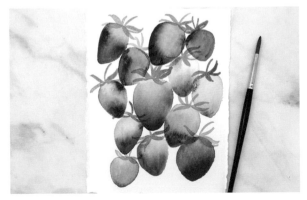

4. Use any of the above-described methods to add seeds to your berries. If you're using watercolor, I like to use Burnt Umber and a round 2 brush.

5. Optionally, use white gouache and a round 2 brush, or a white ink pen, to add highlights around some of the seeds.

3. When the paint has dried, use Hooker's Green to paint in leaves and stems. I like to have the leaves pointing upward.

Mountains

One thing to keep in mind about any landscape painting is that you should be able to split it into three general parts: the background, the middle ground, and the foreground. In the background are the objects that are farthest away. They should be painted small and with less detail. In the foreground are the objects that are closest to the viewer—they appear to be larger, more detailed, and with contrasting values. And in the middle is, of course, the middle ground, with values and details in between the two.

You will explore this idea in a very simple way in this exercise. Because the sun is setting behind the mountains, the mountains in the back are lighter in value and have less detail. Moving toward the middle ground, the mountains have more detail and increase in value because they are farther away from the sun. The key to this painting is being very patient and allowing each layer to dry completely before moving on.

Paint: WN Yellow Deep, WN Opera Rose, WN Ultramarine Violet, WN Ultramarine Blue, WN Prussian Blue, WN Payne's Gray **Brush:** PH Round 16 and 6 **Additional Materials:** Masking Fluid and Brush, Soapy Water

1. Mask a small circle at the top right of your paper. Allow to dry completely.

2. Charge your round 16 brush with a mixture of Opera Rose and Ultramarine Violet and paint a graded wash at the top of your paper. Use clean water to paint a gradient down to the bottom of your paper. Allow this layer to dry completely.

3. Use a light value of Ultramarine Violet to paint the first mountain ridge. Paint the layer all the way down the page. Allow the paint to dry completely.

4. Paint the next mountain ridge using a mixture of Ultramarine Violet and Ultramarine Blue. You want the value to be slightly darker than the ridge in step 3.

5. Continue painting ridges down the bottom of your page using darker and darker values. To darken the values, add increasing amounts of Ultramarine Blue, then Prussian Blue, and finally Payne's Gray.

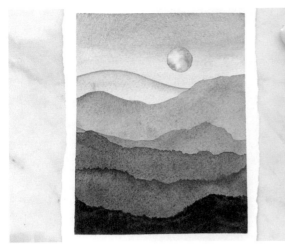

6. Remove the masking fluid and paint the sun using Yellow Deep. Use the wet-on-wet method to add some Opera Rose.

GRASSY FIELD

Practice your landscapes with this lovely grassy field, using Yellow Deep, French Ultramarine, Manganese Blue Hue, Sap Green, Yellow Ochre, Brown Ochre, and Payne's Gray.

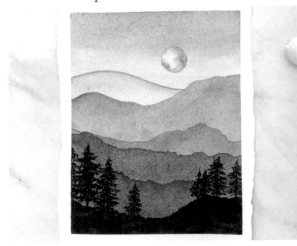

7. Charge your brush with Payne's Gray and paint a silhouette of trees.

Birch Tree Landscape

This landscape requires a few more steps and details compared to the previous ones, but the result is worth it! Birch trees always remind me of fall, so I like to paint the foliage in yellows and browns. This is still a loose style, so have fun with it and try not to get too focused on details.

Paint: WN Lemon Yellow, WN Yellow Deep, WN Manganese Blue Hue, WN Sap Green, WN Yellow Ochre, WN Brown Ochre, WN Burnt Umber, WN Payne's Gray **Brush:** PH Round 10 and 2 **Paper:** Magnani Round Watercolor Block Italia 140 lb. Cold Press **Additional Materials:** Masking Fluid, Brush

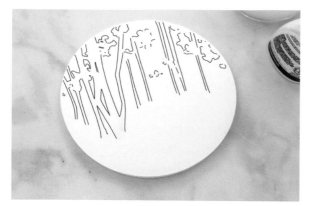

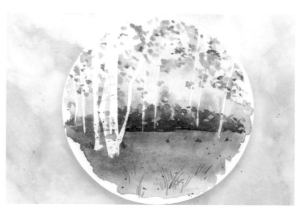

1. Use masking fluid to paint vertical lines to mask off tree trunks. Use rapid up and downstrokes to mask off areas of foliage and sky. Allow the masking fluid to dry completely. I've added outlines to the image for visibility purposes.

3. Use the scumbling method to add details over the first layer. The foliage will be a mixture of Yellow Deep and Yellow Ochre. The darker areas are Yellow Deep, Brown Ochre, and Burnt Umber. The shrubs in the back are a mixture of Sap Green and Payne's Gray. The grass blades and splatter are a mixture of Yellow Ochre and Sap Green.

4. Carefully remove the masking fluid.

5. Switch to the smaller brush and add details and shadow to the trees using a mixture of Payne's Gray and Burnt Umber.

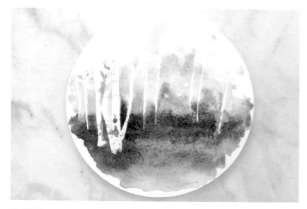

2. Wet your paper completely. Use the wet-on-wet method and a round 10 brush to paint the first layer. From the bottom to the top, I used Yellow Ochre, Sap Green, Payne's Gray, Brown Ochre and Sap Green, Yellow Deep, and Lemon Yellow.

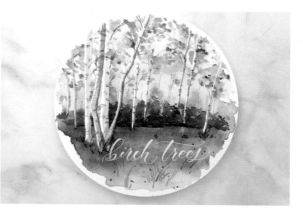

6. Paint in white areas around the foliage with Manganese Blue Hue. Add additional foliage using mixtures of Lemon Yellow, Yellow Deep, and Yellow Ochre.

OTHER IDEAS

DAHLIA

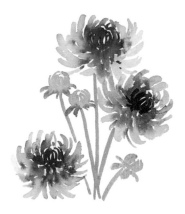

ANEMONE

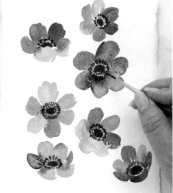

CITRUS SLICES

PALM LEAF

LAVENDER

GRAPES

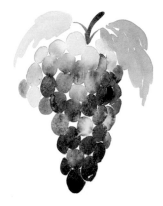

CORYPHANTHA

PRICKLY PEAR

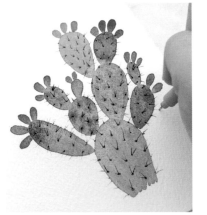

WATERMELON

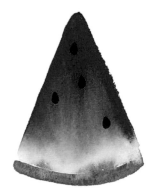

Lettering Fundamentals

Before we start on the fundamentals, let's clear up some definitions. You may have heard of calligraphy, typography, and lettering. Often, the three are used interchangeably. But there actually is a difference between them.

CALLIGRAPHY: This term stems from the Greek words *kalli-* (beautiful) and *graphein* (writing), or literally, beautiful writing. This definition refers mainly to European Calligraphy. Writing is done in single careful strokes to produce beautiful letters. Traditionally, the writing is done with a nib and ink. Different nibs are used to produce different styles of calligraphy.

TYPOGRAPHY: Typography is the art of creating repeatable, legible type. The end result is the words you see on this page now. The letters are vectorized, meaning they are converted from pixels into paths, allowing images to retain clarity even when resized. And everything from the kerning (space between the letters) to the width of each stroke to determining serif or sans serif, have been carefully and painstakingly thought out. Basically, each of the letters and characters has been pre-formed and can be moved around.

LETTERING: Lettering is the art of drawing letters to create a work of art. It may or may not be legible—which is quite different from calligraphy and typography. An individual letter may look different depending on the word it is in, and even in the same word, because there is much more importance placed on the composition of the entire piece, rather than on making the work legible and repeatable. There are many different styles of lettering, much as you would see many styles of handwriting.

For the purposes of this book, I will use the terms lettering, brush lettering, and modern calligraphy interchangeably.

A FEW MORE DEFINITIONS

Much like when you first learned to write, guidelines are necessary and important. Let's break down the guidelines into terms:

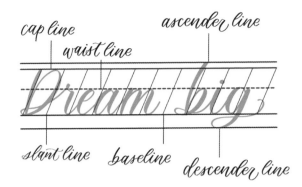

ASCENDER: The part of a letter that rises above the waist line (b, d, f, h, k, l). The ascender is also known as an extender.

ASCENDER LINE: Denotes the height of the tallest ascenders. May extend beyond the cap line in serif fonts, but not always.

CAP LINE: Denotes the height of the majuscule (capital) letters. The cap height can equal the ascender height.

WAIST LINE/X-HEIGHT: Notes the height of a lowercase x. The x-height marks the height of all letters without an ascender.

BASELINE: The line at which the bottom of all letters (except those with descenders) sit.

DESCENDER: Also called an extender or a tail, this is the part of a letter that falls below the baseline.

DESCENDER LINE: Denotes the level to which the descenders extend.

MINUSCULE: Lowercase letters.

MAJUSCULE: Uppercase/capital letters.

SLANT LINE: Not always drawn in, this guideline serves as a reminder of how much to slant each stroke.

DOWNSTROKES AND UPSTROKES

The first and most basic thing you need to know about modern calligraphy is that each letter is made up of thick and thin strokes. In contrast to cursive, the writer must pick up their pen after each of these strokes. The pressure of a downward motion creates the thick strokes. Moving the pen upward releases pressure and creates the thin, hairline strokes.

When using a pointed pen (a pointed nib and a pen holder), the pressure of a downstroke will open the tines (ends of the nib), releasing ink onto the paper. The thickness of the line will depend on the width of the space between the tines. Releasing pressure during an upstroke will close the nibs and release less ink, resulting in a thin hairline stroke.

When lettering with a brush or a brush pen, the concept is fairly similar. The pressure of a downstroke will bend the end of the brush, creating a thicker stroke. Releasing pressure during an upstroke results in a thinner line because you are using the thinnest part of the brush, the tip.

It's best to practice calligraphy lettering with whole arm movements rather than just moving your fingers or your wrist. Whole arm movements are steadier and allow for more freedom—especially when flourishing (page 72).

HOW TO POSITION YOUR PAPER

Rather than having your paper straight, rotate the top of your paper counterclockwise by bringing the top left corner of your paper toward you (if you are left handed, see Tips for Those Who are Left-Handed below). The more your lettering is slanted, the more you will tilt the paper.

HOW TO HOLD YOUR PEN

Hold your pen or brush at an angle rather than upright. Rest the barrel of the pen in the thenar space (fleshy area between thumb and index finger). Holding your writing instrument in the thenar space allows for larger and more natural whole arm movements. Holding it more upright will cause your pen to fray more easily. In addition, holding the pen upright limits your movements to only those that your fingers can make.

TIPS FOR THOSE WHO ARE LEFT-HANDED

After doing some research on the subject and interviewing several left-handed calligraphers, I've developed some helpful tips for those of you who are left-handed. But righties, read this too!

1. Rotate your paper clockwise by bringing the top right corner of the paper toward you. The more slanted your lettering, the more you will rotate your paper.

2. Keep your hand in the "under" position. This means that the wrist should be fairly straight and the hand should be *under* the line of writing. This eliminates much of the smearing that can occur as a left-handed letterer.

3. Use a guard paper. Though this applies to both left and right-handed letterers, it is even more important for left-handed letterers to use to avoid smearing. A guard paper can be a scrap of paper, a tissue, or even a sleeve. Just make sure it's clean. You can use tracing paper if opacity is an issue.

4. Everyone should be lifting after every stroke, not just left-handed letterers. However, for left-handed letterers, the hand can block the view of letters that have already been written. Lifting after each stroke allows you the chance to see what you've already written and make sure that you're maintaining the proper spacing, alignment, and slant.

5. Slow down! Again, this is not a unique concept to left-handed letterers. But it is so important to allow time for ink/watercolor to dry to minimize smearing.

BASIC STROKES

Try the following exercises by placing tracing paper over the provided guidelines. Start with a small-tipped brush pen for now. Once you feel confident in making these strokes without tracing the guidelines, repeat the exercises with a watercolor brush and watercolor paper. Notice that it takes much less pressure to make the downstrokes when using a brush versus a brush pen.

When making a downstroke, start at the top of the stroke (at the ascender line) and apply pressure before you start tracing the stroke. The tip of your pen should bend slightly. Keep a consistent amount of pressure as you move down the line. Take your time. Each stroke should take about 2 seconds. Release pressure only after you have reached the baseline.

When making an upstroke, start at the bottom of the stroke (at the baseline). Move upward with very light pressure to make a hairline stroke. You should be using the very tip of your pen. As with the downstrokes, each stroke should take a few seconds.

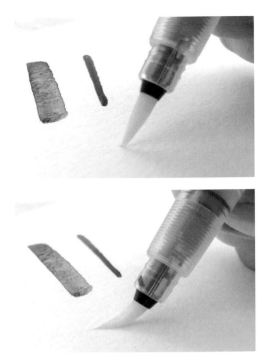

FOUNDATIONAL STROKES

As mentioned earlier, the combination of thin and thick strokes gives brush lettering its distinctive look. Here, we will learn about foundational strokes. With an exception of a few, every letter in the minuscule alphabet is made up of a combination of these foundational strokes.

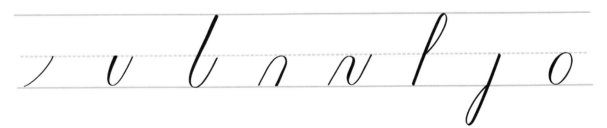

ENTRANCE STROKE: Used to start a word or a letter, and to connect letters. To write this stroke, start at the baseline and curve gently upward toward the waist line. Lift the brush when you get to the waist line.

UNDERTURN: To write this stroke, start at the waist line with full pressure and curve downward. As you reach the baseline, slowly release pressure while still moving your pen to the right, creating a u-shaped curve. You should notice a nice transition between thick and thin. Continue up to the waist line with very little pressure, then lift your brush at the waist line.

UNDERTURN (EXTENDED): This stroke is very similar to the underturn, except it begins at the ascender line. Start as you would a full pressure down-stroke. But before you reach the baseline, begin to release pressure and complete the stroke the same way you did with the underturn.

OVERTURN: This stroke is the exact opposite of the underturn. Start at the baseline with little pressure and move upward by pushing your pen toward the waist line. Without increasing pressure, make a curve to the right. Allow the pen to touch the waist line and pull the pen downward without adding pressure. After you have completed the curve, add pressure as you descend toward the baseline. End this stroke with full pressure.

COMPOUND CURVE: This curve combines the overturn and underturn. All three lines should be parallel. As the middle line is created with a down-stroke, it is the only line that requires pressure. Start this stroke as you did the overturn. However, before you reach the baseline, begin to release pressure. End the stroke as you would an underturn.

ASCENDING STEM LOOP: Begin this stroke with little pressure at the waist line. Push your pen upward and as you approach the ascender line/curve of the stroke, begin to curve to the left. After hitting the ascender line, pull your pen downward. Start to add pressure a little below the ascender line and end the stroke with full pressure.

DESCENDING STEM LOOP: This stroke is the exact opposite of the ascending stem loop. Begin this stroke at the waist line with full pressure. As you approach the descender line/curve of the stroke, start to release pressure. Curve to the left and end this stroke at the baseline with a hairline (thin) upstroke.

OVAL: This is one of the most difficult strokes to master. With little pressure, start the oval around 1 o'clock rather than directly at the top of the oval. Without adding pressure, push your pen upward in a counter clockwise direction. Then, curve down and to the left, and begin to add pressure around 11 o'clock. The stroke should be thickest around 9 o'clock. Begin to

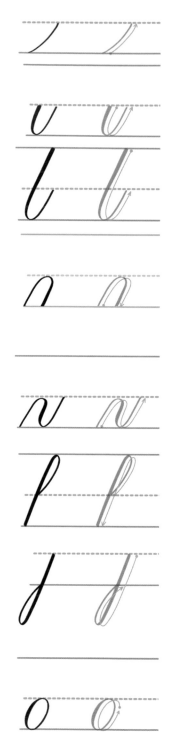

release pressure at 7 o'clock as you curve to the right. Resume upward toward the starting point with little pressure.

These strokes should be practiced regularly to build up muscle memory. When first starting out, I filled pages and pages with just these strokes. They are also a great exercise for loosening up prior to lettering. I still go back to these foundational strokes when I haven't lettered in a while. Remember that each stroke should be written quite slowly—allow about 3–4 seconds per stroke.

While it is quite enticing to skip these strokes and move directly to the alphabet, I strongly discourage doing so. I see many people struggling with lettering when they don't start with the basics. When these same people go back to the basics and start again, something seems to click for them and lettering becomes so much easier. Writing the letters seems easier, connecting the letters makes more sense, and their lettering drastically improves. So take it one step at a time and build yourself a good foundation.

#

The style of lettering we will start with is very simple but elegant. Notice that almost every letter is made up of the strokes you learned in the previous chapter. It is perfectly acceptable to practice the letters in alphabetical order. Another way to learn them is by categorizing them:

Category 1: Foundational Strokes

The letters a, g, h, m, n, u, and y are written using the basic strokes.

Category 2: Foundational Strokes plus

The letters i, j, k, o, t, v, w, and x are written using the basic strokes plus one other unique stroke.

Category 3: Variations/Combinations of the foundational strokes

The letters b, c, d, f, l, and q contain a variation of the foundational strokes or a combination of a few foundational strokes.

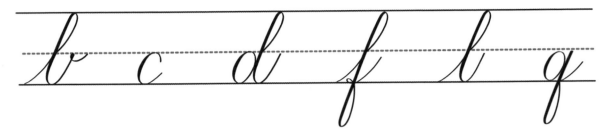

Category 4: Outliers

The letters e, p, r, s, and z are not made up of the foundational strokes. Some of these strokes resemble or contain parts of basic strokes. For example, the e is similar to a miniature ascending stem loop. The r and s both start with entrance strokes, and the r ends in an underturn. But these letters all contain a unique stroke that cannot be found in letters in the other categories.

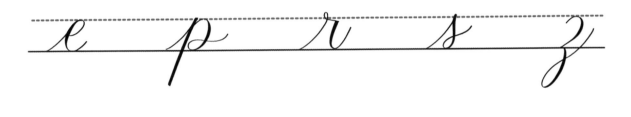

PRACTICE

When practicing writing the letters, be sure to go slowly, and lift your pen after every stroke.

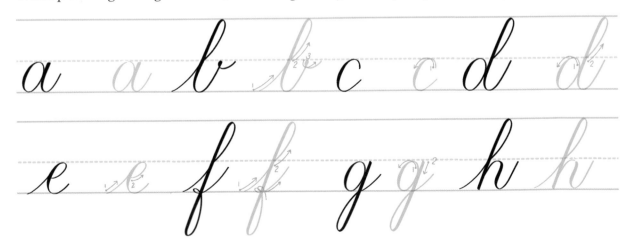

i i j j k k

l l m m n n o o

p p q q r r

s s t t u u v v

w w x x y y z z

Connecting Letters

Now that you understand how to form each letter, you will learn how to connect them to make words. Making connections between letters can be tricky. If you followed the guidelines as they were presented, then for many of the letters, connecting them is as simple as putting them next to each other. There are, of course, variations, so to break things down I have outlined a few strategies to help you. Take some time on these next few pages to practice making connections.

1. For the most part, the end of the first letter takes precedence over the beginning of the subsequent letter.

2. Here are some general rules for the letters that *end in an underturn* (a, d, h, i, l, m, n, r, t, x, u):

- If the subsequent letter starts with an oval/oval variant (a, c, d, e, g, o, q), simply place the that letter next to the end of the underturn.

- If the subsequent letter starts with an entrance stroke (b, f, h, i, j, k, l, p, t, u, w, y), the upstroke of the underturn on the first letter becomes the entrance stroke for the next letter. In other words, remove the entrance stroke of the second letter and place it next to the underturn of the first letter.

- If the subsequent letter does not fall into the previous two categories (m, n, r, s, v, x, z), the last upstroke of the underturn of the first letter merges into the beginning of the subsequent letter without lifting your pen.

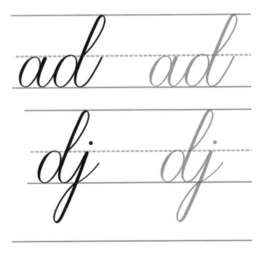

3. For the letters that end in a "tail" (*b, o, v, w):*

- If the subsequent letter starts with an oval/oval variant (a, c, d, e, g, o, q), simply place the subsequent letter next to the end of the "tail."

- If the subsequent letter starts with an entrance stroke (b, f, h, i, j, k, l, p, t, u, w, y), the end of the "tail" of the first letter becomes the entrance stroke for the subsequent letter. In other words, remove the entrance stroke of the subsequent letter and place it next to the tail of the first letter.

- If the subsequent letter does not fall into the previous two categories (m, n, r, s, v, x, z), the "tail" of the first letter takes precedence and merges into the beginning of the subsequent letter.

4. For the remaining letters (c, e, f, g, j, k, p, q, s, y, z) that end in an upstroke, the rules remain the same as those that end in an underturn, with one minor exception:

- If the upstroke of the first letter meets an ascending stem loop (b, f, h, k, l), extend the upstroke until it meets the waist line to create a more natural flow of your letters.

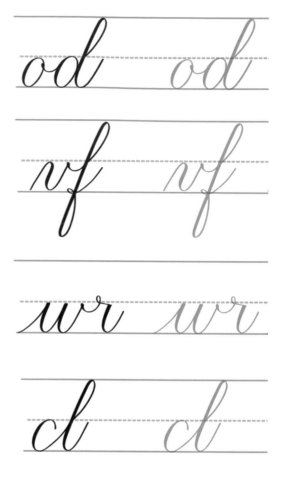

The following page contain a few more examples to practice connecting letters. As you practice, remember the first rule: the ending strokes of the first letter take precedence over the beginning of the subsequent letter. As always, remember to write slowly and lift your pen after each stroke.

aa db he if ah hi

rj am tr ds ax av

az xn bb ve of wi

ba bp or vx ws ca

ei fm sh

Stylistic Variations

When I work on hand lettered designs for clients, I want to be able to provide many different styles of lettering for them to choose from. So a few years ago, I created a systematic method that allowed me to make subtle changes to my lettering that would change the overall style. You built a good foundation in Chapter 5, and learned a simple, but widely usable, style of lettering in Chapters 6 and 7. Now you can move on and learn how to modify these letters and find a style you feel comfortable with.

It is a good idea to have multiple styles in your lettering repertoire to offer options for potential clients. You may want a casual style for a party, or a more elegant style for a formal dinner or a wedding. And if you're just interested in learning for personal knowledge, these variations will help you find a personal style that feels comfortable to you. Some of these variations may seem very subtle, but you would be surprised at how small changes can make a difference in the overall look of your lettering.

You are welcome to write in the pages of the book, or use tracing paper over the book. You'll find practice lines on page 75, which you can write on directly, make copies of, or write on with tracing paper. There are additional practice lines at the back of the book. When you're feeling confident enough, try the changes on your own on a separate sheet of paper.

VARY THE BASIC STROKES

WEIGHT OF A DOWNSTROKE: Possibly the simplest of all variations, this can be achieved by applying more or less pressure during a downstroke.

Here are two examples of how you can increase the thickness of your downstrokes. The upstrokes were also thickened to achieve a nice balance between the two strokes. Note that you might have to switch to a bigger brush to achieve very thick downstrokes.

down *down*

Practice varying the pressure and thickness of your downstrokes.

TAPER: Rather than applying full pressure all the way to the end of a downstroke, reduce pressure sooner to taper the ends of the stroke. This subtle change is most easily noticed with thicker downstrokes, as seen in the examples below.

taper taper

Practice tapering your strokes.

VARY EACH FOUNDATIONAL STROKE

As you discovered earlier, the foundational strokes make up almost every letter in the lowercase alphabet. Therefore, by manipulating the strokes, you can vary your lettering style.

OVAL

THINNER OR THICKER: For a thinner letter, make sharper turns at the waist line and baseline to create a thinner oval. For a thicker letter, make a wider turn at the waist line and baseline to resemble a circle more than an oval.

In the examples below, you can see that the ovals have changed in thickness. Feel free to keep the under-turns and other strokes the same thickness or adjust to match the width of the ovals.

oa oa oa oa

Practice changing the width of your ovals.

SMALLER: Smaller ovals result in a bouncier and more modern look. As the ovals get smaller, the x-height also moves down. This means that ascenders and descenders also start at the same height as the ovals.

Practice writing with smaller ovals.

TALLER: Bringing up the x-height results in taller ovals. Letters that fall below the waist line, such as c and e, will also be taller.

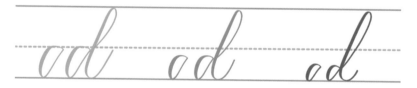

Practice writing taller ovals.

MORE TRIANGULAR: Replace the top curve with a straighter top that drops down at almost a 90-degree angle. This is the "oval" that I use most often for modern calligraphy.

Practice writing triangular ovals and note that the size of the oval decreases.

OPEN OVAL: Rather than making a complete oval, start writing the oval at 1 o' clock as you normally would, but end the oval at around 2 o'clock

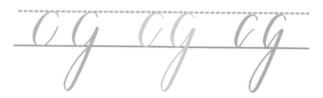

Practice writing the open ovals. Note that the latter two are more triangular ovals.

ASCENDERS/DESCENDERS

SHORTER: Bring down the ascender line to write shorter ascenders. This results in a style that looks more casual and compact.

Practicing writing shorter ascenders.

CURVED: Apply a slight curve to all ascenders and descenders. As seen in the examples below, this results in a more modern look to your lettering. Play with varying amounts of curve to find the amount that suits you best. You can apply curves to the other downstrokes, as well.

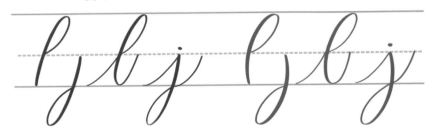

Practice curving your ascenders and descenders.

TALLER: Bringing up the ascender line for taller ascenders. This results in a wispier, more graceful style.

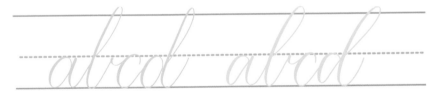

Practice writing taller ascenders. Note that the second style has triangular ovals and curved ascenders.

ADD FLOURISH: Flourishes add drama to lettering. We will revisit flourishing on page 72, but simple ascender and descender guides are provided below. They are simply elongated compound curves. Write them with little to no pressure.

S-SHAPE CURVE: Apply a slight s-shaped curve to all descenders.

Practice writing s-shaped descenders. The exemplars have thicker downstrokes and triangular ovals to match this modern style.

f g j y

ENTRANCE/EXIT STROKE: Entrance strokes can be varied in many ways. In the word "live," both the entrance and exit strokes have been extended with a large dramatic curve. In the word "laugh," the entrance stroke has been flipped over into a subtle overturn. In the word "love," both strokes have been lifted near the waist line, rather than starting/ending at the baseline.

live laugh love

VARY THE BASELINE I (BOUNCE LETTERING)

This stylistic variation is one of the hallmarks of modern lettering. It is also a little tricky to master. The basic principle of bounce lettering is to vary the baseline within a single word in order to create the illusion that the letters are "bouncing." It sounds simple enough, but there are certain letters that look much better with a bounce than others. While there aren't any specific rules, here are a few tips to help you achieve this look.

abcde hello

1. Ovals and circular letters are typically more aesthetically pleasing with a higher baseline.

2. Letters with ascenders typically look better with a lower baseline.

3. Try to alternate between higher and lower baselines. When adding a bounce to your lettering, having multiple letters in a row that are high, or multiple in a row that are low, may throw off the overall look of your lettering.

4. Practice! This technique is definitely one of the harder ones to master. Don't feel discouraged if you don't get it right away.

Practice bounce lettering.

VARY THE BASELINE II

In this exercise, you will be varying the baseline within a single letter. Here are a few guidelines to help you master this variation:

1. Again, ovals look best with a higher baseline.

2. Extended underturns look best with a lower baseline.

3. The underturn of a compound curve (h, m, n, v, and x) looks best with a lower baseline.

4. Letters with underturns (with the exception of the letters i, y, and the first underturn of u and w) look best with a lower baseline.

VARY THE LETTER SPACING

The space between each letter, or even within a letter, can also be varied. Wider spacing with long, wispy connectors results in a casual but elegant look. Whether you choose to increase or decrease the spacing between your letters, take care not to make extreme changes, as this can decrease legibility.

Practice varying the spacing of your lettering using the guides provided above. Notice that in the word "love," the spacing within the letters themselves have been increased.

VARY THE SLANT

Changing the slant of your lettering definitely changes the style. Increasing the slant to a word may add elegance but can also decrease legibility. Letters with no slant are more legible and appear less formal. Some styles of calligraphy have a specific angle to which the letters slant. For example, Copperplate slants at a 55-degree angle. For modern calligraphy, I like to slant at around a 45-degree angle. Whichever way you decide to slant your lettering, be sure to keep it consistent within a single style of lettering.

Practice varying the slant of your lettering using the practice guides provided below.

choose joy *choose joy*

FLOURISHING

While not a true variation, the addition of flourishes adds drama to any style of lettering. When used sparingly and tastefully, flourishes can add elegance and flair to a piece. Unfortunately, it can also detract from a piece if poorly thought out. There are no hard rules as to when you can add flourish, but there are some general guidelines you can follow to get you started.

- Use thin lines when flourishing to keep your letters legible. Thick lines can quite easily look like letters and confuse the reader.

- Don't over-flourish. It is a matter of taste, but not every single letter needs a flourish.

- Good letters to add flourishes to are those with ascenders, descenders, and cross bars (the line that crosses a t). Other good places to add flourishes are at the beginning or end of a word, or at the bottom or top of a piece.

- Tiny flourishes don't add to a piece, while giant, oversized flourishes definitely distract from a piece

- As with most things, flourishing is a matter of personal preference and the amount and type of flourishing you do can define your style.

- Keep practicing and try new flourishes to see what fits your personality!

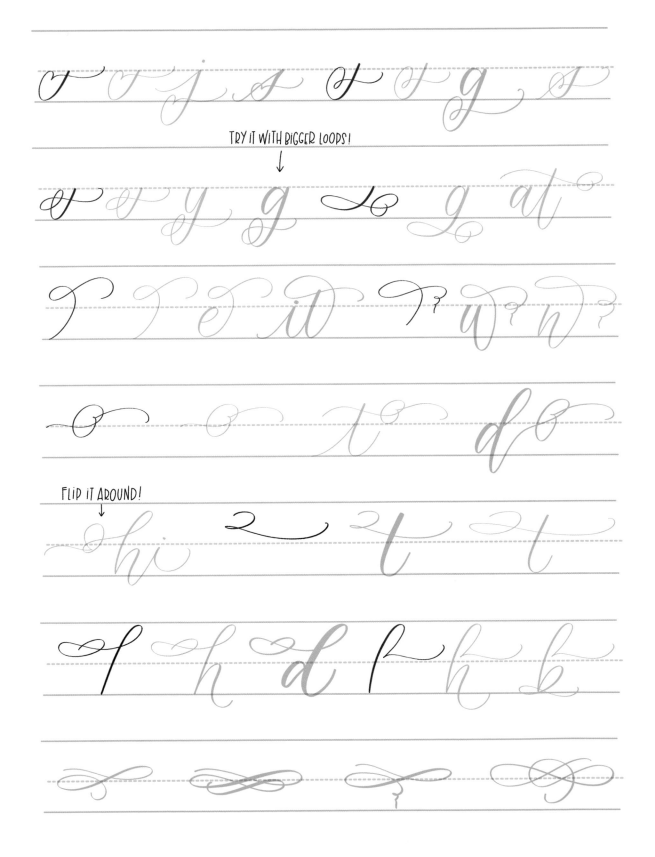

TRY IT WITH BIGGER LOOPS!

FLIP IT AROUND!

Note that when flourishing with a watercolor brush, it's easiest to do so by changing the grip on your brush. Holding the brush more upright allows the brush to glide more easily along your paper, resulting in smooth and natural flourishes. This takes quite a bit of practice, as this type of grip can also reduce the amount of control you have on your brush. As always, use whole arm movements when flourishing, rather than moving just the wrist or fingers.

MINIMUM PRACTICE

Now that we have gone over different stroke variations to help you mix up your style, here is a fun exercise with even more practice. When I'm warming up, I like to write out the word "minimum." As you write this word, you'll notice that it is a series of overturns and underturns. This exercise helps you practice the transition between thin and thick lines. In addition, you will understand how little variations in strokes create changes in lettering styles. As you practice tracing the words below, try to see what changes I made to create a particular style of lettering. Remember to go slowly and pick up your pen after every stroke!

minimum *mihimum*

mihihum *minimum*

mihimum *mihihuh*

Capital Letters

You may have wondered why we've stuck to lowercase letters only up until this point. Unlike lowercase letters, capital letters do not have a specific set of strokes that make up each letter. Though some of the letters do share similar strokes and curves, many do not. For this reason, they can be trickier to master. The following pages contain exemplars of different styles of capital letters. In the same way we varied our lowercase letters, you can vary these by changing the slant, thickness of letters, curves, etc., to better suit your personal lettering style.

As with all the previous lettering exercises, use tracing paper and a brush pen to practice by tracing over the style of letter that you like best. Once you feel comfortable, switch over to a paintbrush and watercolor.

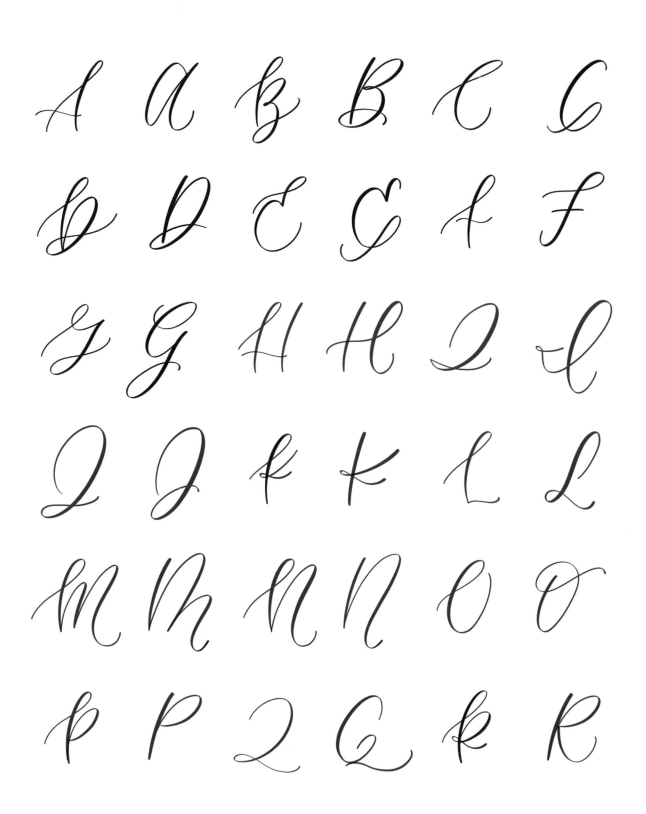

S S I T U U

V V W W X X

Y Y Z Z

CHAPTER 10

Watercolor Lettering

Now that you understand the basics of both watercolor and lettering, it's time to put the two together.

Before each session of watercolor lettering, I like to take out a scrap piece of watercolor paper, or even regular printer paper, and practice my foundational strokes. I recommend that you do so as well. This will help you loosen up and get used to lettering with a brush. You'll find it is quite different from lettering with a brush pen. The brush is much more flexible, and therefore it will give more easily, making it a little more difficult to control. Give yourself time, and you'll soon get used to it!

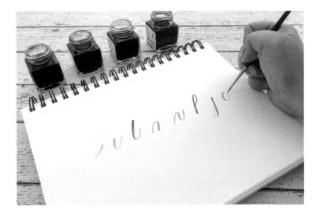

The following pages contain exemplars of complete alphabets in different styles of lettering. The exemplars are larger than those in the previous chapters so they can be used with a watercolor brush or a water brush. Place tracing paper over the exemplars just as you did with the brush pens; you will have to use minimal water. If you're having trouble, try it with a brush pen, and once you feel comfortable, try lettering on watercolor paper.

TIPS ON LETTERING WITH A BRUSH

- Get familiar with the flexibility of your brush by starting with some foundational strokes.
- For lettering, use a bit less water than you would when painting. Your brush should be damp, but not dripping.

- Start out with liquid watercolor. You'll find it easier to use than mixing your own watercolor paint and water. If you choose to mix your own paint, do so in a small well rather than on your palette.

- If you're having trouble going directly from a brush pen to a paintbrush, start out with a water brush instead. The nylon bristles are a bit stiffer than a watercolor paintbrush.

- If you choose to use a watercolor paintbrush, start with a smaller tip such as a 0 or 1 round rather than one with a longer tip.

- When you're ready to letter on watercolor paper, start out with a smooth-finish paper such as Legion Stonehenge Aqua 140 lb. Coldpress, Strathmore 500 Series Cold Press watercolor paper, or the more economical student grade Canson XL 140 lb. watercolor paper.

Each of the following three styles has been created utilizing the techniques discussed in the previous chapters. Before each exemplar, I've listed some characteristics of the foundational strokes that make up that particular style of lettering. Keep the list in mind while attempting each style to better help you master each one.

HARPER

Style: A simple and casual style that has no slant.

Downstrokes: Thick and slightly curved.

Ovals: Slightly slanted and subtly triangular.

Ascenders/Descenders: The ascenders have no loop. The ratio between the x-height to ascender/descender height is high.

JESS

Style: A modern and bouncy style of lettering. This is my signature style of lettering and the one I use most.

Downstrokes: Thick and curved.

Ovals: Triangular.

Ascenders/Descenders: Large loops adorn the ascenders and descenders.

Baseline: Varies from letter to letter, and even within a letter, resulting in a bouncy look.

ANDIE

Style: A wispy and graceful style of lettering.

Downstrokes: Thin, curved, and tapered, with not too much difference in thickness between upstrokes and downstrokes. You will notice that not every downstroke requires pressure (for example, the letter M). Also note that some letters, like S, are standalone, and do not connect to other letters.

Ovals: Small (shorter x-height).

Slant: Exaggerated.

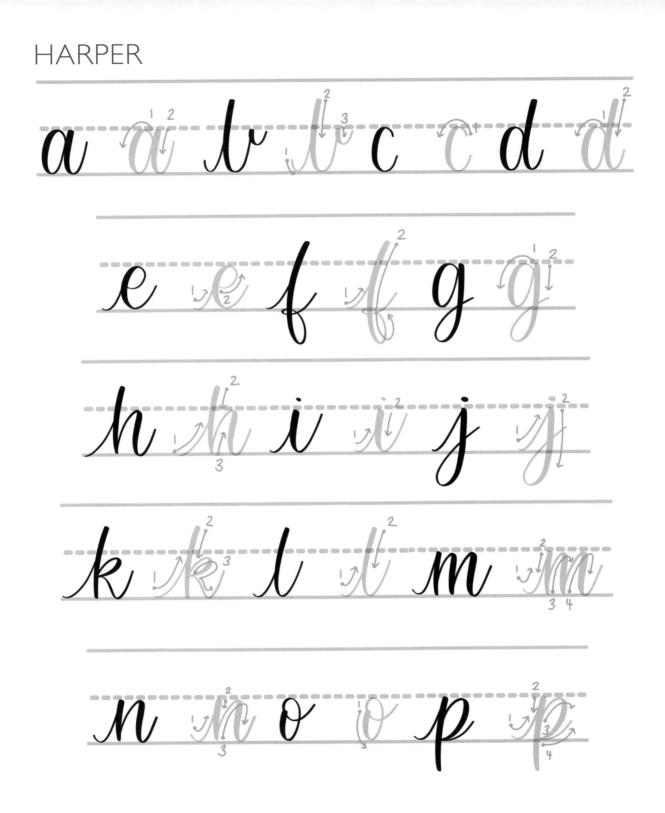

q q r r s s

t t u u v v

w w x x y y

z z

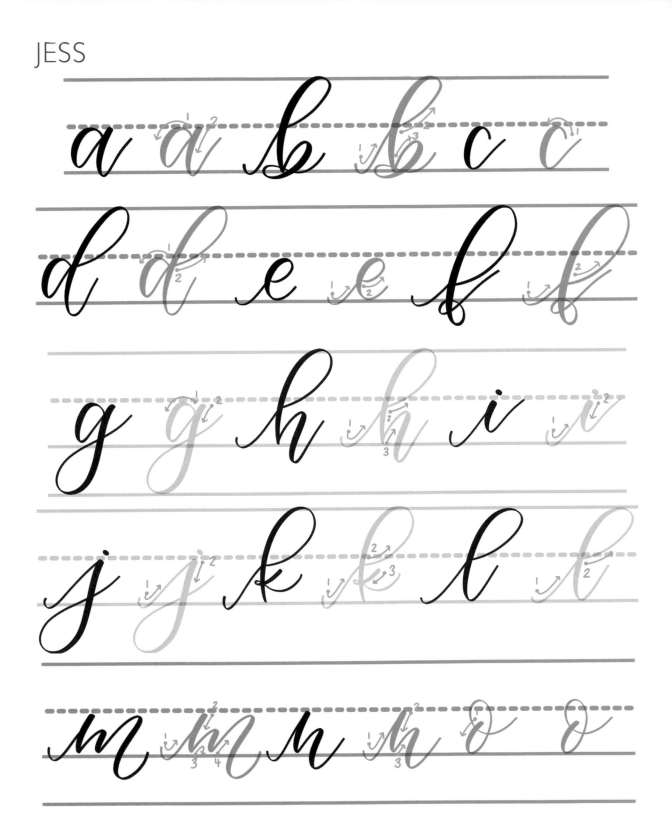

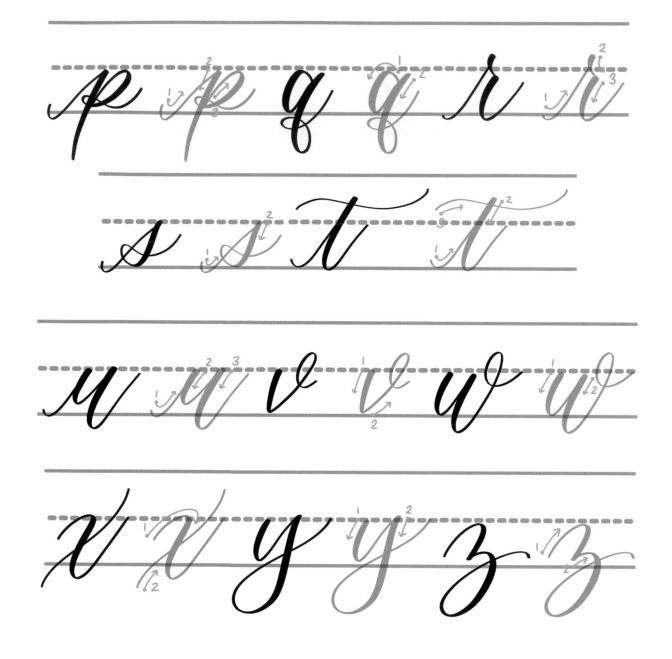

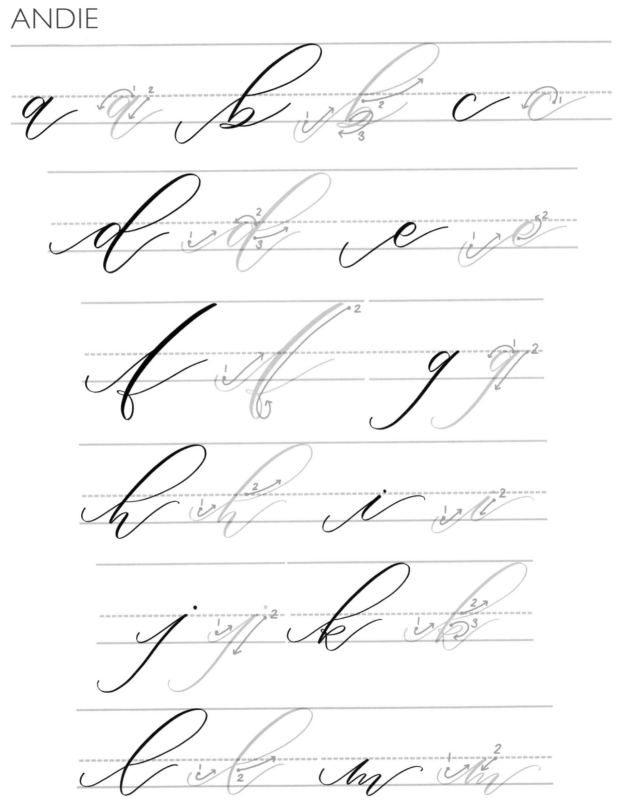

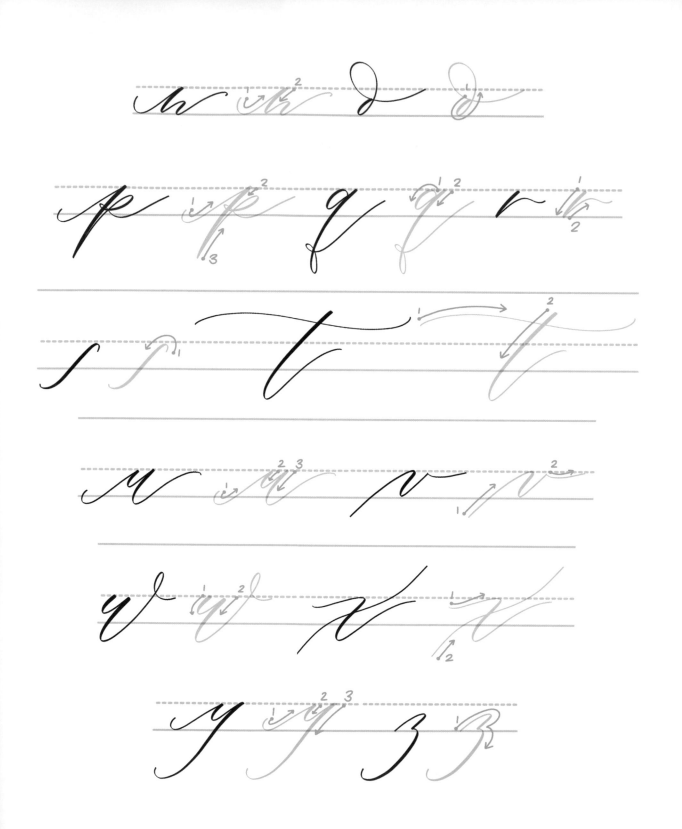

WATERCOLOR LETTERING TECHNIQUES

Now that you have a few different lettering styles in your repertoire, you can learn how to embellish them using different watercolor techniques. Though some of these techniques can be done with brush pens, the resulting effect is not quite the same as it is with watercolor. It is possible to blend some brush pens, but there is nothing that can imitate the bleed of watercolor.

Think back to the gradient and variegated washes you practiced in the first half of the book. There really was no way to control those perfect blooms of color. When I think of watercolor lettering, I think of perfect, unpredictable little blends and blooms within the strokes of a letter. They're the hallmark of watercolor lettering.

For these exercises, unless otherwise stated, I am using a Pentel Aquash Waterbrush Small or Medium (unfilled), Royal Talens Ecoline Liquid Watercolor, and student grade Canson XL 140 lb. Cold Press watercolor paper. If you choose to use tube or pan watercolor instead of liquid, you can premix the colors with water into separate wells to achieve the same effects.

One-Color Lettering with a Paintbrush

Brush: Princeton Heritage Round 2

1. Charge your brush with a single color. Hold the brush as you would a brush pen and letter the first stroke.

2. Re-dip your brush and move on to the next stroke.

TIP: Go slowly. Remember, the faster you move your brush against watercolor paper, the more textured it will be. You can use this to your advantage if you want the appearance of textured lettering.

3. Continue like this until you've written the entire word.

One-Color Gradient with a Water Brush

In this exercise, you will create one-color gradient lettering. It is the easiest of the gradient watercolor techniques you will learn, but it still has a gorgeous effect.

Paint: Ecoline Liquid Watercolor 507 (Ultramarine Violet)

1. Dip the tip of your water brush into the liquid watercolor. (Alternatively, you can use a pipette to transfer a few drops of liquid watercolor into a well on your palette.) Charge your brush, gently wiping off the excess liquid on your brush by sliding it across the rim of the well.

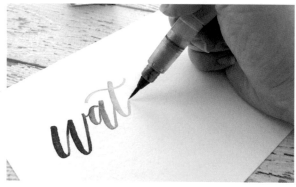

2. Begin to write your first letter, moving slowly and steadily. Any pausing will cause your paint to

pool and result in hard edges. This is perfectly acceptable and an aesthetic choice. If you prefer an even blend, try to keep your movement consistent and do not allow the paint to dry between each stroke.

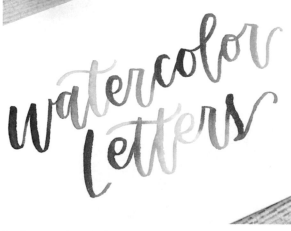

3. As your brush begins to deposit pigment onto the paper, the colors will naturally fade, creating a nice gradient. At this point, dip your brush back into the paint and keep writing.

Multicolor Gradient

Here, we are going to use two colors to create gradient lettering. This same technique can be used with three or more colors. Thinking back to the chapter on color theory and color harmony, choosing complementary colors will result in a piece that looks harmonious and pleasing to the eye. But don't be afraid to try new combinations. You might just be surprised! For example, I love to use dark violet and lime green

together. The green is such an unexpected pop against the violet. For this exercise, I used Ecoline Liquid Watercolor 640 (Bluish Green) and 580 (Pastel Blue).

Brush: Princeton Heritage Round 2

1. Select a few colors of liquid watercolor and have them readily available so you can dip directly into the jar. Alternatively, you can use a pipette to transfer a few drops of liquid watercolor into separate wells on your palette.

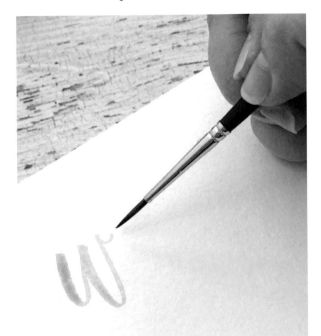

2. Charge your brush in the first color, gently wiping off the excess liquid on your brush by sliding it across the rim of the well.

3. Begin to write. After a few strokes, rather than dipping in the first color again, dip your brush in the second color and continue to write. You'll notice that the new stroke will be a mixture of the two colors. If you would rather have two separate colors, then rinse your brush in clean water and blot dry before dipping into the next color.

Wet-on-Wet

In this next exercise, we are going to lay down a single letter in one color, and then add additional colors to it using the wet-on-wet technique. Try not to control how the colors blend, but rather let them flow naturally. Touching up the paint too much can result in a muddy, overworked appearance.

Color: Ecoline Liquid Watercolor 508 (Prussian Blue), 522 (Turquoise Blue), 666 (Pastel Green), 580 (Pastel Blue) **Brush:** Princeton Heritage Round 2

1. Charge your brush with a color of your choice.

2. Write out the letter of your choice, taking care to use enough liquid to allow the paint to stay wet for a few minutes.

3. Rinse out your brush, blot to dry, and charge your brush with a new color.

4. Gently dab your brush in the wet areas of your lettering. Watch as the colors blend and bleed, it's quite mesmerizing!

TIPS AND VARIATIONS

- This technique works best when you start with a lighter color then add a darker one to it. But you'd be surprise to see that some lighter colors are able to hold their own and push through even darker colors.

- If you're not using liquid watercolor, or if you are rinsing between colors, it's important to blot your brush dry completely before picking up the next color. Excess water will create uneven drying, and therefore, hard edges in your blends.

- When writing a whole word rather than a single letter, be sure to use enough liquid for the base color to stay damp. This can be achieved by completing one letter at a time, or by going over each letter again to rewet it. I recommend the former method rather than the latter.

Simple Ombré

For this exercise, you will learn a simple way to create ombré lettering. As you recall, ombré is basically a gradient. An ombré can go from light to dark, or blend into another color. Here, you will learn how to do the latter.

1. Fill a water brush with your choice of liquid watercolor or ink.

2. Dip the hairs of the water brush into a second color of your choice.

3. Begin to write and notice that the first stroke is a mix of the two colors.

4. When the second color runs out, the first color will take over. At this point, redip your brush and keep writing. Try different color combinations and see what you like best.

Simple Ombré (Multiple Lines)

Building off of the previous styles, this next lettering style adds the element of composition. You must work rather quickly to allow the letters to blend and touch.

1. Pick out a short quote that you would like to letter. It should be at least three words, or long enough to break up into 2–3 lines.

2. Figure out a composition that is aesthetically pleasing to the eye. Make sure everything appears balanced. (For help on composition, see Chapter 11.)

3. Pick out a few colors of liquid watercolor that will blend nicely together. Start writing the first line of your quote.

4. Using a new color, write the next line of your quote directly underneath the first line. Find areas where letters can touch. For example, allow a descender on the first line to touch an ascender on the second line.

5. Repeat step 4 with the next line of your quote.

Once you feel comfortable with this style of lettering, try it again, but this time, change the color after every stroke or letter.

TIP: This style of watercolor lettering looks best with a bouncy lettering style. If you're having trouble finding areas where the letters can touch, refer back to the Jess style of lettering.

ALTERNATIVE METHOD: This technique can also be achieved with brush pens and liquid watercolor. Simply replace the water brush with a water-based brush pen of your choice. Dip the brush pen directly into the liquid watercolor and begin to write.

This works best with larger-tip brush pens, as most tend to be water-based. Examples include Ecoline watercolor brush pen, Tombow Dual Brush pens, and Sakura Koi Watercolor brush pens. These brushes are all self-cleaning, meaning that if you continue to write with them, the dipped color will fade out and the pen will return to its original color.

NOTE: This technique may permanently discolor the fibers on the tip of your brush pen, but it is purely an aesthetic change. The performance of your brush pen will not be compromised.

Vertical Ombré

This style of ombré lettering, as well as the next, is one of the most difficult. When I think of vertical ombré lettering, I like to think of every downstroke as a smooth, gradated, variegated wash. The gradient starts at the top and gradually changes color as it goes down. You can choose to have the ombré going from light to dark, or dark to light.

- Always start the base with the lighter color. Adding a lighter color over a darker color may not be visible.

- Add a minimal amount of dark color for a gradual gradient. Adding too much of the darker color can overpower the lighter color and make the ombré difficult to see.

- Be sure to add the darker color while the lighter color is still damp. If you allow the first color to dry, you will not get the ombré effect.

- Try to steer away from complementary colors. For example, if you choose red and green, they'll turn to mud when blended. Instead, choose colors that are closer to each other on the color wheel, such as pinks and purples, or blues and greens. Or, choose a variation of the same color, such as two reds or two greens.

1. Choose two liquid watercolors, a light and a dark, that you would like to blend.

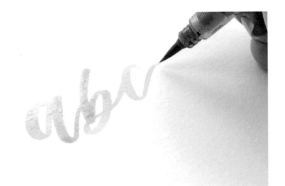

soon to add more paint. When it is just a nice sheen on your paper, it is the perfect time to add paint. Locate the downstroke of your letter and gently dab the top of it with your brush. You should notice the darker color immediately blending in to the lighter color.

5. Rinse your brush again and recharge with the lighter color. Gently blend the two colors together in short up and downstrokes.

2. Write the first letter of your word using the lighter color. Be sure to use enough water and paint for the letter to stay damp for several seconds.

3. Work quickly, rinse off your brush, and blot it dry. Charge with the darker color.

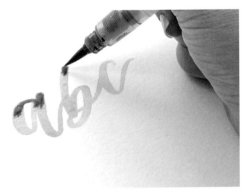

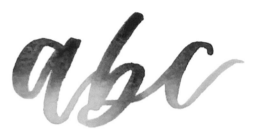

6. Go back with the darker color and repeat steps 4 and 5 until you are satisfied with the ombré effect.

4. Examine the first layer of paint you have laid down on the page. If it is a pool of paint, it is too

TIPS AND VARIATIONS

1. If you have two brushes, you can designate one for the lighter color and one for the darker color to avoid rinsing between colors.

2. In this exercise, the ombré started on top with the darker color and ended with the lighter color. You can certainly do the reverse. To achieve this, add the darker colors to the bottom of the downstroke rather than the top, and blend as normal.

3. Choose one color and use water as the other color. To do this, you'd repeat the above steps using water as your lighter color, and liquid watercolor as the darker color. This method is a little tricky, as the water can be difficult to see on your paper. But the result is also very beautiful.

4. Add a third color between the light and dark colors. For example, I will often do "ocean/beach" lettering with three different colors for the sand, water, and sky.

Horizontal Ombré

I saved horizontal ombré for the last of the ombré tutorials because it requires paint mixing, which can get a little tricky. The basic concept is the same. You will be creating letters that gradually change values horizontally across the page. To do so, you will be using a lighter color and a darker color. The difference is that you will premix colors rather than allowing them to blend on the page. The reason is that with lettering, you use up and downstrokes, which makes it easier to blend vertically. With horizontal lettering, you need to really think about the value scale and how to create gradually darker values.

I. Choose two colors—a lighter color and a darker one. You will need two clean wells on your watercolor palette. Using a pipette, place a few drops of the lighter liquid watercolor in one well, and a few drops of the darker color in the other well.

2. Charge your brush with the lighter of the two colors. Write the first stroke of your first letter.

3. Working quickly, mix the paint for the next color. Dip the very tip of your brush in the darker

color. Mix it in the first well with the lighter color. It should be slightly darker now.

4. Write the next stroke, allowing the two strokes to touch and blend.

5. Working quickly, and without rinsing your brush, dip the very tip of your brush in the darker color and mix it with the lighter color. Write the next stroke of your word.

6. Repeat steps 3–5 until your word is complete. The very last stroke should be purely the darker color.

TIPS AND VARIATIONS

1. If you have a large amount of words to write, you will want a more subtle gradient. To achieve this, mix only a very small amount of dark color with your lighter color between each stroke.

2. If your word is short, you'll want to achieve the gradient faster. To do so, mix a larger amount of the darker color to the lighter color between each stroke.

3. It is possible to go from light to dark, and then back to light again. Depending on how dark your darker color is, it may be tricky. But the basic idea is the same. Start with a small amount of darker color and add gradual amounts of the lighter color to lighten the value.

4. You can treat each line like a new ombré. In other words, begin each line with the same color and end it with the same color.

APPLYING THE TECHNIQUES

Now that you understand some of the basic watercolor lettering techniques, let's take it a step further and explore different ways to use these techniques.

Galaxy Lettering

Galaxy lettering is a trending style that is actually much easier than it appears. Think back to the Wet-on-Wet lettering exercise on page 89—this is exactly that but with different colors and embellishments added at the end.

With galaxy lettering, I typically letter with clear water, but without proper lighting it can be very difficult to see clear water on white paper. So, I recommend dropping a few drops of liquid watercolor in your water container to give it a slight tint.

Paint: Royal Talens Liquid Watercolor 700 (Black), 507 (Ultramarine Violet), 640 (Bluish Green), 666 (Pastel Green) **Additional Materials:** Cotton swab, rubbing alcohol, Dr. PH Martin's Bleed Proof White

1. Using water, or lightly colored water, letter a word of your choice.

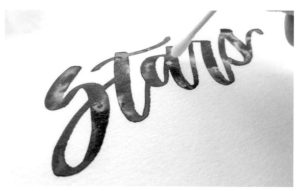

2. Using the wet-on-wet method, dab the colors of your choice into the water. Allow some white spaces for a nebulous look.

3. Sparingly add dabs of Pastel Green.

6. Dip the cotton swab in alcohol. Pick a few areas on your letters to dab, being careful not to overdo it.

7. Allow the painting to dry completely. There should be no sheen left on the paper.

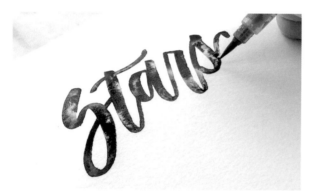

4. While the paint is still damp, very carefully dab in areas of black. Take care not to overwhelm the lettering with black so there are still areas of color peeking through.

5. Add some dabs of clean water for more nebulous areas.

8. Using Dr. PH Martin's Bleed Proof White and a medium-sized brush, utilize the splatter technique to add "stars" to the lettering. This can also be achieved using a white ink pen (such as a Sakura Gelly Roll).

TIPS AND VARIATIONS

1. Adding colors while the lettering is very wet will result in colors that are not dispersed. Adding colors while the lettering is damp will result in colors that bleed much further. You can use these qualities to your advantage when trying to decide just how much you want the "dabbed" colors to disperse.

2. Try substituting the white for gold or metallic watercolor/ink to add shine to your lettering.

3. Cover the areas of your paper you don't want splattered by laying down some scrap paper.

4. Be conservative with and mindful of the amount of paint and colors you are using in your work. Too much dabbing of too many colors can result in a muddy appearance.

Landscape Lettering

Gradient washes are used to create this type of lettering. It is a type of ombré lettering that uses specific colors. In this example we will be painting a desert landscape.

Paint: Ecoline 226 (Pastel Yellow), 361 (Light Rose), 390 (Pastel Rose), 507 (Ultramarine Violet) , 700 (Black)

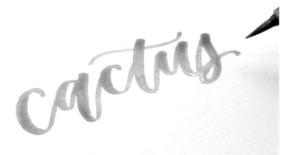

1. Start with a very light pink color such as 390 (Pastel Rose) and write your first letter.

4. At the very bottom of the letter, use black (700) to paint the ground and a cactus.

These last two techniques are not unique to watercolor lettering, but can be added to any type of lettering.

2. At the very bottom, dab a bit of yellow (226) followed by a richer pink such as 361.

3. At the very top, dab a dark purple (507). Blend the colors if necessary. Allow the paint to dry completely.

Outlining

This technique is exactly what it sounds like—outlining your lettering. I find it not only makes the letters pop, but it also makes the piece as a whole look a bit more casual and cartoon-y. In addition, it can mask any areas of bumpy/uneven lettering. The outlining can be done in any color, but black, gold, silver, and white are what I use most commonly. I find it easiest to do this technique with a pen such as the Sakura Pigma Graphic 1.

1. Allow your watercolor lettering to dry completely.

2. Use your pen to outline the outside edge of all your letters. Take care when outlining areas where strokes cross and overlap.

Shadows

Adding shadows to lettering is a common technique but can be difficult to understand. The resulting effect gives the illusion that there is a shadow behind your lettering that makes the letters appear that they are popping out of the page.

To understand where to put a shadow on your lettering, you'll have to imagine a light source shining on your letters. When light hits an object, where do the shadows fall? If you answered to the opposite side of an object, you are correct. If you are facing the sun, the front of your body will be brighter, your back will be darker, and you will cast a shadow on the ground behind you. So, for example, if an imaginary light source is shining to the left of your lettering, the shadows will be on the right. If the imaginary light is to the left and above your lettering, the shadows will be down and to the right.

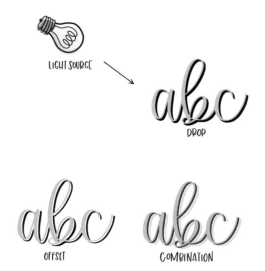

Depicted in the illustration, we see three types of shadow effects. These are just a few possibilities that I use, but of course, more do exist. In the top example, we see a drop shadow. It is basically as if you copied your lettering, changed the color, and pasted it below the original.

The second example is an offset shadow. Note the space between the lettering and the shadow—as if the letters were lifted off the page.

The last example is a combination of the previous two styles. The resulting effect is lettering that looks like a 3-D cut out, lifted above the page.

Projects

In this chapter, you will be incorporating everything you have learned so far into beautiful finished projects. From home décor to invitations and signs, my hope is that through these step-by-step projects, you will gain the confidence to keep creating beyond what this book offers.

COMPOSITION

No matter how beautiful a painting is, or how elegant the lettering is, a poor composition can really be very distracting. So before you begin your first project, it's time for a brief discussion regarding composition. There is so much information available on the subject and it can get very overwhelming, so we will stick to the basic information needed to make simple projects.

Before starting any painting or lettering project, I recommend creating a thumbnail sketch. Using a pencil and regular printer paper, draw a small rectangle in the same dimensions of your paper but at a smaller scale. Sketch out where you want different elements of your design to go. I will even place blobs of color where I want different paintings so that I know the colors will look harmonious together. Once you are happy with your sketch, you can refer to it as you work on the final draft.

These are some of the elements that take a composition from good to great.

MAKE IMPORTANT ELEMENTS STAND OUT: Whether it's something as simple as a gift card or something more complex, you want to make sure that the important elements in your design stand out. Some ways to do this are with color, size, and placement of the important elements.

AVOID CLUTTER: Not every square inch of your design has to be filled. You want to give the viewer a place to rest their eyes. The white space in a painting can be just as important as the rest of the composition.

USE COLOR TO YOUR ADVANTAGE: Think about where you want the eyes to focus and use color to guide the viewer.

CHECK ALIGNMENT AND SPACING: One of the easiest ways to throw off a composition is to have crooked lettering. Be sure to draw guidelines or use a laser level to keep your words straight. Make sure that your design is centered on the page or aligned in a way that is pleasing to the eye.

STICK TO ODD NUMBERS: For whatever reason, the human eye finds odd numbers to be more appealing than even numbers. When painting a cluster of flowers or berries, three will look nicer than two or four.

STICK TO THE RULE OF THIRDS: If you decide to split up your composition, splitting it in three will look nicer than in half. For example, when painting a landscape, put your horizon at the top or bottom third of the page rather than in the middle. If you have a lone figure in your photo, paint it along the right or left third of your paper instead of dead center.

Gift Tags

Personalized gift tags are a beautiful way to share your newfound skills of watercolor and brush lettering. You can start with something as simple as a flat wash or paint an all-over floral pattern. I will be using a gift tag punch, something that can be found at any arts and crafts supply store such as Michaels or online on Amazon.

Paint: Watercolor of choice Brush: Small round watercolor brushes Paper: 140 lb. cold press watercolor paper Additional Materials: Pencil, ruler, single-hole puncher, scissors or gift tag punch, fine liner pen, ribbon or twine

1. Measure out the height of your gift tag. My gift tag punch punches out a height of 2³⁄₁₆ inches (5.3 cm).

2. Using a ruler and a pencil, lightly draw a line all the way across the edges of your paper at the height of your gift tag. For example, I would draw my line 5.3 cm from all four edges of my paper.

4. Allow the paint to dry completely. If using a gift tag punch, align the bottom of your paper with the bottom of the punch. Carefully punch/cut out your gift tags.

5. Punch a single hole at the top of your gift tag and loop ribbon or twine through the hole. Secure with a knot.

6. Use a fine liner brush to write "To:".

3. Paint a floral pattern all along the bottom third of the edges of your paper.

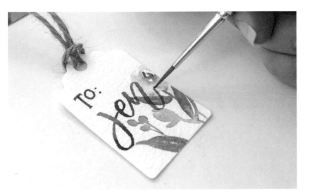

7. Use a small round paintbrush (such as a round 1) to letter the name of the recipient in the color of your choice.

TIPS AND VARIATIONS

- If the floral pattern seems too intimidating, try it first with a simple wash. Repeat the same steps as you did earlier, but replace the floral paintings in step 3 with a wash of your choice.

- Add textures to your wash with water, splatter, and lifting.

- Try adding elements of gold watercolor to the edges of your gift tags by running the edges of your paper along a paintbrush loaded with gold paint.

- Letter the names with watercolor only and without a floral background or a wash. The one-color or two-color gradient is always a good choice.

- Skip the ruler and measuring and paint a pattern that covers the entire gift card. The possibilities are endless!

Place Cards and Escort Cards

Place cards and escort cards add an elegant touch to any special gathering. Escort cards are used to tell guests at which table to sit, while place cards assign guests to specific seats. At large gatherings, it is possible to have escort cards without place cards, but not the other way around, unless you want your guests to wander around looking for their seats.

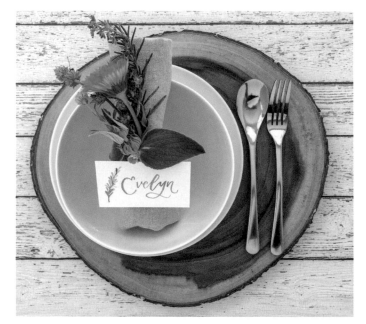

Whether you decide to have one or both, like the gift tags, there is a lot of room to be creative. You can go with something as simple as a wash or choose to paint more detailed botanicals.

Paint: Watercolor of choice
Brush: Medium and small round watercolor brushes **Paper:** 140 lb. cold press watercolor paper **Additional Materials:** Pencil, ruler, scissors or paper cutter

1. Using a pencil, lightly draw 2 x 3½-inch rectangles (or 4 x 3½-inch, if you choose to fold them in half and have them stand like a tent) onto your paper.

2. Paint different herbs or leaf elements on the left-hand side of your paper using the medium-size watercolor brush.

3. Optionally, use a pencil to lightly sketch out names on the right side of each of the escort or place cards. Then, use a small paintbrush (such as a 1 or 2 round) and the colors of your choice to letter the name. Add a table number if necessary. Allow the paint to dry completely.

4. Cut out each card. Fold in half if you chose to make tented cards.

Love You to the Moon and Back

This abstract moon is perfect as a baby shower gift or as an addition to a nursery. Because it's abstract, you can customize the colors as you please. The gold splatters are beautiful accents to the painting of the moon. The lettering can also be done in gold if you wish.

When painting a large wet-on-wet wash such as this, we use a lot of water so be sure to paint on a block, tape your paper down, or use 300 lb. watercolor paper. I will be painting on a block.

Paint: Watercolor of choice Brush: Large and medium round watercolor brushes (such as sizes 10 and 6) Paper: 140 lb. cold press watercolor paper Additional Materials: Pencil, gold/metallic watercolor, cotton swab, rubbing alcohol, salt

1. Using a pencil, lightly draw a large circle in the center of your paper. Be sure to leave at least an inch and a half of border space on the sides to allow for framing.

2. Use a large watercolor brush to paint the inside of your circle with clean water. Don't worry about painting in every part of your circle. The dry areas will result in hard edges, which ends up looking very nice.

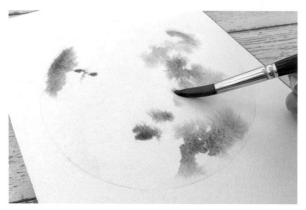

3. Drop in colors of your choice using the wet-on-wet technique. For this painting, I used Ivory Black and Payne's Gray. Continue until you feel satisfied with the value of your colors.

4. Use your paintbrush to drip clean water in different areas around the moon to create texture.

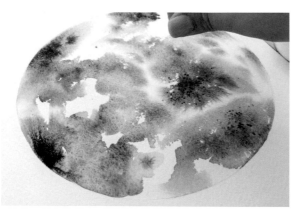

5. While the painting is still wet, you can sprinkle salt in different areas on your painting. It's best to choose one or two concentrated areas rather than sprinkling the crystals around the entire painting. Adding salt at this step rather than when it's more dry results in more unpredictable textures.

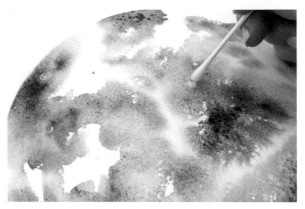

6. Allow the painting to dry to a light sheen. At this point, you can further create texture by using a cotton swab dipped in alcohol to depict craters on the moon.

7. Add splatter using Ivory Black, Payne's Gray, and white gouache. You can also add splatter using a metallic paint. I used Kremer Pigmente 503008.

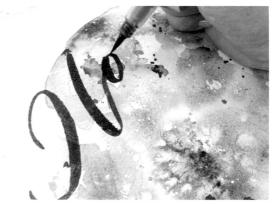

8. Write out the words in the color of your choice.

Botanical State

This one is always a crowd favorite. I've gotten many requests from clients to paint these for bridesmaids, for family or friends who were moving away, or just to display at home. They're beautiful even without the lettering, but I think the addition of the lettering gives it a nice touch. I like to customize each state with the official state flower or plant, but any floral pattern is nice. The use of masking fluid results in crisp clean edges. If you don't have any handy, just be extra careful when painting near the edges.

In this example, I will be painting Arizona—a state I lived in for a few years and really fell in love with. There is nothing quite like an Arizona landscape, and these cacti remind me of the days I lived in the state.

Paint: Watercolor of choice Brush: Round watercolor brushes size 6 and 2, and a brush for masking fluid Paper: 140 lb. cold press watercolor paper Additional Materials: Pencil, masking fluid and soapy water (optional), sand eraser, gouache (optional)

1. Using a pencil, lightly sketch out the shape of the state you will be painting. If you're not confident with your sketching abilities, you can use a tablet to trace the outline of the state. You can also print out the outline and use a bright window or a light pad to trace the shape onto your watercolor paper.

2. Using an old brush and masking fluid, carefully trace the sketched outline of your state.

Be sure to dip in soapy water frequently to avoid clumping of the brush hairs.

3. Once the masking fluid is dry, fill in the insides of the state with the botanicals of your choice. Be sure that they reach the borders to really pronounce the outline of the state. Since I painted cacti, I went back to add details with gouache once the paint dried.

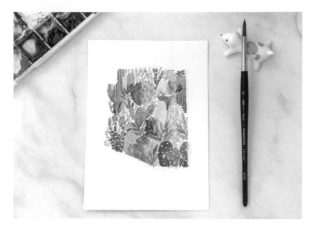

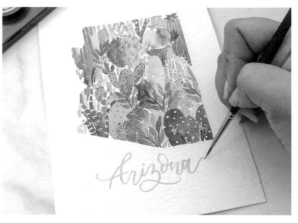

4. Allow everything to dry completely before removing the masking fluid. If you're having difficulties removing the masking fluid, lightly rub with a sand eraser.

5. Use a brush pen or watercolor brush to letter the name of the state at the bottom of the paper

VARIATION: Try it with a country! For example, I once painted cherry blossoms into the shape of Japan and it was a big hit.

Simple Leaf Wreath

Wreaths may seem intimidating at first, but you've already learned how to paint all the basic components. For this wreath, we will keep things simple and use repeating leaf elements. You can choose to do the entire wreath with the same types of leaves or alternate 2–3 different styles around the wreath. It's helpful to mark off equal sections along your circle as guidelines. As you paint more and more wreaths and get more comfortable, you can skip this step.

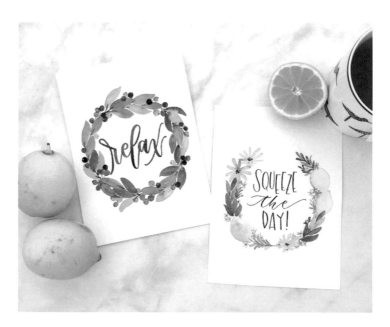

Paint: Watercolor of choice Brush: Round watercolor brushes in sizes of your choice Paper: 140 lb. cold press watercolor paper Additional Materials: Pencil, compass (or a circular object to trace, such as a jar or a large mug)

1. Use your compass or circular object to lightly sketch a circle on your paper.

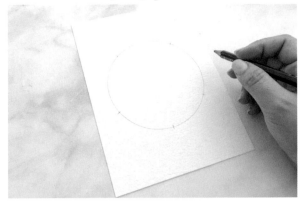

2. Optionally, use a pencil to roughly mark off five equal sections on your circle. Each section demarks a new branch on your wreath.

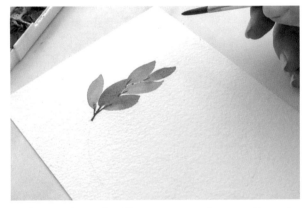

3. Paint a branch of leaves using the pencil marks as a guide. The circle helps with the angle of the branch, and the sectioned-off areas helps you see where to start and stop your branch. Whichever way you pointed your leaves (clockwise or counterclockwise) will remain consistent for the remaining steps.

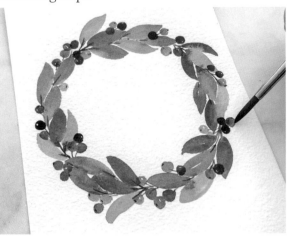

4. Fill in the rest of the sections of your wreath with branches. Be sure to stick with the same direction you painted in step 3. Optionally, add berries to fill in empty spaces.

5. Add lettering to the inside of the wreath with the quote or name of your choice. Be sure that the color of the lettering matches the rest of the elements of the wreath.

Fruit and Floral Laurel

In this project, we will be combining fruit and botanicals to create a laurel. Unlike the Simple Leaf Wreath, there is an opening at the top of the laurel. Laurels also differ from wreaths in that we start the branches at the bottom. The right side of the laurel is painted upward in a counterclockwise direction, while the left side of the laurel is painted upward in a clockwise direction.

Paint: Watercolor of choice Brush: Round watercolor brushes in sizes of your choice Paper: 140 lb. cold press water-color paper Additional Materials: Pencil, compass (or a circular object to trace, such as a jar or a large mug)

1. Use your compass and pencil to lightly trace a circle on your paper. Leave the top portion open.

2. Paint the larger elements of your laurel along the pencil lines, leaving space for leaves and filler elements. In this laurel, the larger elements are the lemons and larger flowers. Keep composition in mind as you are painting. Try to keep an even ratio of color on either side of the laurel. For example, if you put one lemon on the right side and two on the left, then when you paint the larger flowers, balance it out by putting two on the right and one on the left.

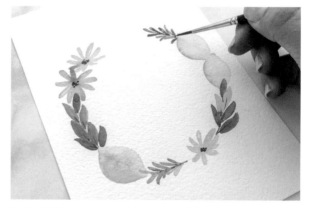

3. Add leaves on either side of the laurel. Remember to keep the composition balanced.

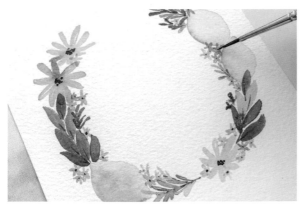

5. Add lettering to the inside of the laurel with the quote of your choice. Be sure that the color of the lettering is one that matches the rest of the elements of the laurel.

4. Add clusters of small purple flowers throughout the laurel.

Here are a few more examples to help spark your imagination when it comes to wreaths and laurels.

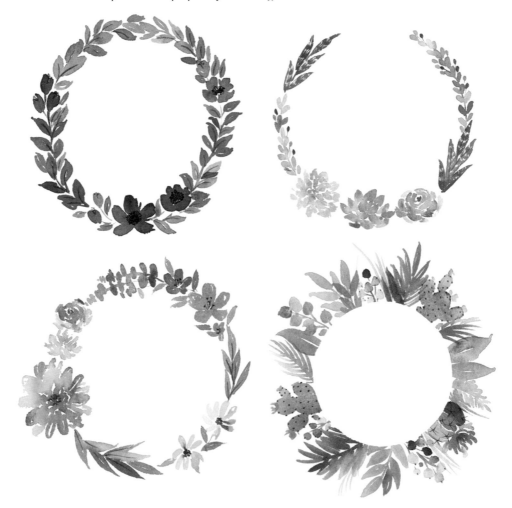

Negative Space Letter

Here, masking fluid is used to create a letter within negative space. You can definitely create this project without masking fluid if you are very careful.

Paint: Watercolor of choice **Brush:** Round watercolor brushes in sizes of your choice, including a brush for masking fluid **Paper:** 140 lb. cold press watercolor paper **Additional Materials:** Pencil, masking fluid, and sand eraser

1. Using a pencil, lightly sketch the outline of a letter of your choice. It can be in script or print. Whichever you choose, keep in mind the final result looks best with thicker lines.

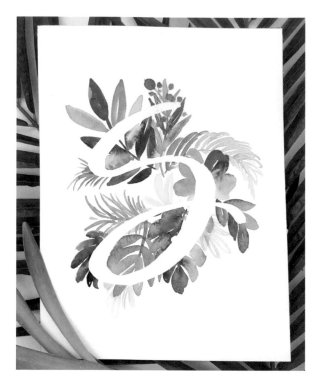

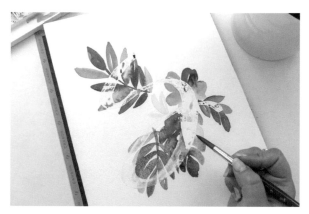

2. Use masking fluid to mask off the areas you don't want painted. I usually mask just the outside edges, not the entire letter. Allow the masking fluid to dry completely.

3. Paint botanicals growing radially and surrounding the letter. You want all edges of the letter to be covered, including any loops.

4. Allow the paint to dry completely. This may take a while, depending on how much water you've used.

5. Carefully remove the masking fluid using the sand eraser.

Decorated Downstroke

This type of lettering requires a good understanding of downstrokes and upstrokes. The decoration can be anything from botanicals to fruit. My favorite version I've done was decorated with donuts! Whatever you choose to paint, the decoration goes on the downstroke of the letter. If the letter has multiple downstrokes, such as in a capital B, you can choose where to put it, but I find it looks best on the largest downstroke of the letter. So, in the case of B, it would go on the first stroke, rather than the "bumps" of the B.

Paint: Watercolor of choice Brush: Round watercolor brushes in sizes of your choice, including a brush for masking fluid Paper: 140 lb. cold press watercolor paper Additional Materials: Pencil, masking fluid, and sand eraser

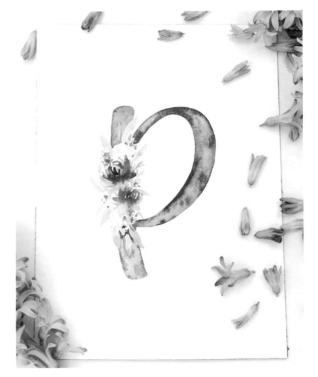

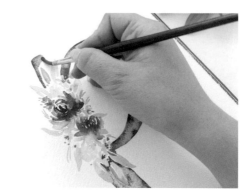

1. Use a pencil to lightly sketch the outline of your letter.

3. Allow the decorations to dry. Then use your choice of color to paint the rest of the letter.

TIP: You can do a single color on your letter or use harmonious colors to paint a wash. If you have trouble painting around the decorative elements, you can mask those elements. Just be sure that they are dry before adding masking fluid.

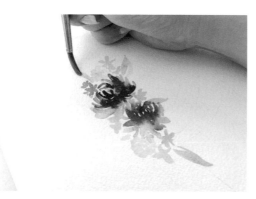

2. Paint your choice of decorations on the downstroke of the letter.

Floral Letter

The final decorated letter in this book is a floral letter. The inside design does not necessarily have to be botanicals; you can paint any design you want! I've even painted entire landscapes and winter scenes within a letter. If you're very careful, you can create the letters without using masking fluid. However, using masking fluid will result in crisp lines.

Paint: Watercolor of choice Brush: Round watercolor brushes in sizes of your choice, including a brush for masking fluid Paper: 140 lb. cold press watercolor paper Additional Materials: Pencil, masking fluid, and sand eraser

1. Use a pencil to lightly sketch out an outline of your letter. Try to keep the width of the letter thick enough to have space to paint inside of it.

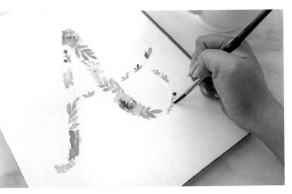

2. Use masking fluid to mask the outside of the letter. Allow several minutes for the masking fluid to dry.

3. Paint the inside of the letter with florals or designs of your choice.

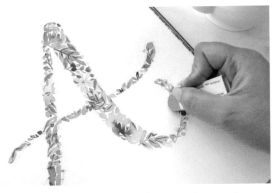

4. Remove the masking fluid using the sand eraser.

Bridal Shower Cup Cake Topper

One of the most fun and meaningful custom designs I made was a wedding cake topper for a friend. In this exercise, you will learn to make mini versions of that. Though this exercise has been customized for a bridal shower, you can change up the wording and make it fit any event you'd like.

Paint: Watercolor of choice Brush: Round watercolor brushes in sizes of your choice, including a brush for masking fluid Paper: 140 lb./300 lb. cold press watercolor paper Additional Materials: Pencil, masking fluid, compass, scissors, bamboo skewer, glue/washi tape

1. Use your pencil and compass to lightly sketch a circle onto your paper. The size I drew was 2½ inches in diameter.

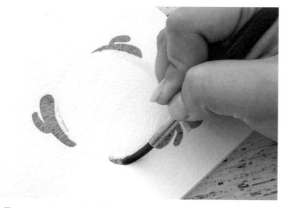

2. Paint a botanical border using the circle as your guide. Optionally, use masking fluid to mask out the inner part of the circle and remove before lettering.

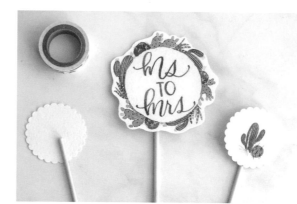

5. Use washi tape or glue to attach the design to the bamboo skewer. Be sure to leave several inches of length for the skewer to stick into the cake. You may need to trim off the excess length.

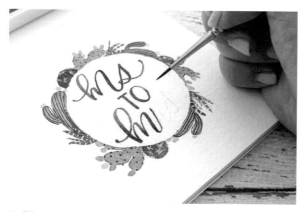

3. Use a paintbrush or brush pen to letter "Ms to Mrs" inside the floral border. Allow the design to dry completely. You may have to dry under a book if it is not drying flat.

4. Use your scissors to carefully cut out your design. I like to leave white border a few millimeters wide around the design.

Birthday Card

One of the best things about learning watercolor and lettering is that you never have to purchase a card again. In this exercise, you will be painting on pre-folded blank watercolor greeting cards. Though it is possible to make your own from paper you have at home, I don't really recommend it. Folding high-quality watercolor paper often causes it to split, tear, or fold unevenly.

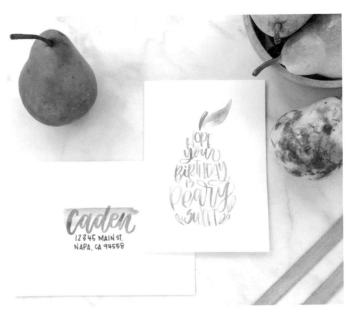

Paint: WN Permanent Sap Green, WN Yellow Ochre, WN Raw Umber, WN Payne's Gray **Brush:** Round watercolor brushes in sizes of your choice. **Paper:** Strathmore Watercolor Cards **Additional Materials:** Pencil

1. Using a pencil, lightly sketch out the shape of a pear on the front of your card.

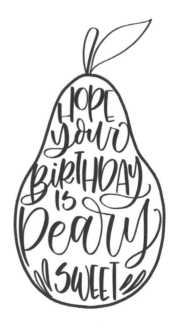

2. Optionally, use a pencil to write out the words, "Hope Your Birthday Is Peary Sweet" within the shape of the pear.

3. Use varying mixtures of Permanent Sap Green and Yellow Ochre to letter the words.

4. Use a mixture of Raw Umber and Payne's Gray to add a stem at the top of the pear.

5. Paint a leaf attached to the stem.

Invitation

Designing and painting your own invitation is a great way to incorporate watercolor and lettering. You can scan your paintings into your computer and incorporate typed print, or you can letter the entire invitation yourself. If you feel uncomfortable with digitizing your paintings, you can find a local printer who is able to do it for you.

Paint: Watercolor of choice Brush: Round watercolor brushes in sizes of your choice Paper: 140 lb./300 lb. cold press watercolor paper Additional Materials: Pencil

1. Use your pencil to mark off a 5½ x 7½-inch rectangle on your paper.

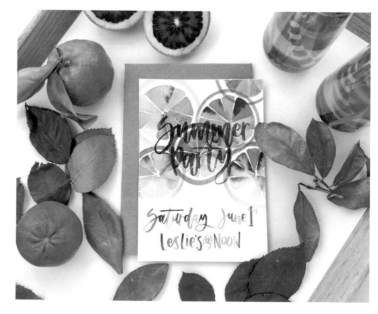

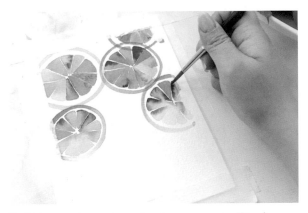

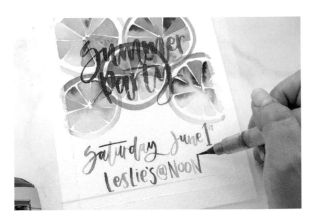

2. Paint various citrus in the rectangle. Don't worry if the paint extends past the rectangle.

3. Pick a color that matches your design and letter the details on your invitation.

4. Scan and print your design. Trim the paper down to a 5 x 7-inch size. If you're using a professional printer, be sure to let your printer know that you'd like your design to be trimmed to a full bleed, meaning there will be no white border around your design.

Menu

Creating a handwritten menu for your guests adds a nice personal touch at any dinner party. It doesn't need to be fancy or intricate, as you can see in this following project. And you can easily tailor the colors to match your tablescape or party theme.

Paint: WN Manganese Blue Hue, DS Cobalt Turquoise, WN Winsor Green (Blue Shade), WN Brown Ochre, WN Payne's Gray **Brush:** Round watercolor brush in the sizes of your choice **Paper:** 140 lb./300 lb. cold press watercolor paper **Additional Materials:** pencil, vellum paper, scissors, Tombow MONO Permanent Adhesive, Tombow Fudenosuke Brush Pen, Hard Tip

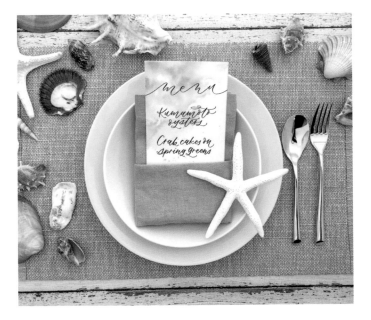

1. Use your pencil to lightly mark off a 4 x 8-inch rectangle on your watercolor paper.

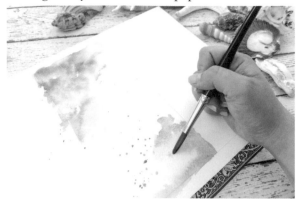

2. Paint a wash on the paper using the ocean-themed colors. Allow the wash to dry completely.

3. Cut out the rectangle. Alternatively, if you need a large amount of copies, you can scan, print, and cut out each menu. If you painted to the edge of your paper and choose to use a professional printer, be sure to let your printer know that you'd like your design to be trimmed to a full bleed, meaning there will be no white border around your design.

4. Cut your vellum paper to a 4 x 8-inch rectangle.

5. Letter the menu items on the vellum paper using a brush pen.

6. Lay the vellum over the watercolor paper and attach using the adhesive.

Troubleshooting

As with any new hobby, you may find yourself running into problems. This chapter is focused on tackling some of the most common problems encountered with watercolor and lettering.

TROUBLESHOOTING LETTERING

My thin lines are shaky

When first starting out, it's common to have shaky thin lines. Don't try to make up for it by lettering faster. Go slowly. Try to loosen your grip and relax while lettering. Use whole arm movements rather than relying on finger movements. Lastly, don't forget to breathe! Keep practicing and eventually it will become muscle memory.

I'm having trouble transitioning thin and thick lines

If you're having trouble with transitions between thin and thick lines, try writing larger and thicker letters. Exaggerate the thick lines with more pressure to increase the contrast between thin and thick. Write slowly and gradually release/increase pressure so you can feel exactly where to make those pressure changes. The best foundational stroke to help you practice this transition is the compound curve.

Another great exercise to do when practicing this transition is to write out the word "minimum." The word contains a series of under and overturns, allowing you to practice this transition over and over. See page 74.

You may find yourself wanting to grip your pen more tightly while doing this exercise. This will result in tight unnatural strokes and make it difficult to make the thin and thick transition. Try to relax your grip and be patient with yourself.

I'm noticing multiple lines when I write thin lines

If you're noticing thin scraggly lines alongside your letters when using a brush pen, the tip of your pen has likely frayed. This occurs with overuse or when using your brush pens on less-than-ideal paper. Recall that there are some papers that have smoother finishes and are kinder to your brush pen tips (see Chapter 1).

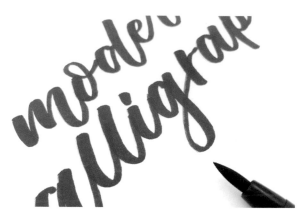

If you notice this when using watercolor and a brush, then this occurs when the hairs of your brush are not keeping their shape. To remedy this, be sure to use a high-quality round tip brush that keeps its shape even when wet. Refer to Chapter 1 on how to choose a brush, and page 125 on how to reshape a brush.

I'm having trouble keeping smooth lines when flourishing

As with most skills, flourishing comes with practice. That being said, it's best to flourish (and letter!) with whole arm movements rather than from the fingers or wrist. Using just finger or wrist movements keeps your movements stiff and limited. Keep your wrist locked and make sure you have enough space to move your arm around. I like to allow my forearm to glide across my writing surface when flourishing. The desk steadies my arm a bit, and the whole arm movement results in a smoother flourish.

I'm having trouble writing in a straight line

Though you can write out guidelines, sometimes, like when you are writing hundreds of place cards, it's just not practical to do so. For these types of projects, I like to use a laser level. Any inexpensive one will do but my favorite one is the Black & Decker BDL220S Laser Level. The light is close to the bottom of the level. It is quiet (there are loud motorized ones out there!) and small.

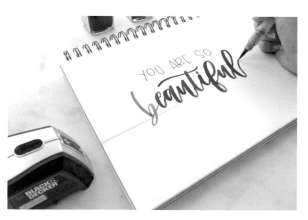

I'm having trouble keeping the size of my lettering consistent when writing

This is definitely a skill that comes with practice. In the meantime, draw yourself guidelines or use the blank guideline sheets that come with this book. The bare minimum you need is a baseline, a waist line, and an ascender line. I also like to include slant lines to keep my slant consistent.

TROUBLESHOOTING WATERCOLOR

Paper is Warping/Buckling

Paper warp when some parts are wetter than others are causing the paper to stretch in the wetter areas. This can be remedied in several different ways:

1. WATERCOLOR BLOCK: Though your paper may still buckle while painting, a watercolor block has all sides of the paper tacked down. This means that the paper will eventually flatten down while it is drying.

2. MASKING TAPE/PAINTER'S TAPE AND HARD SURFACE: This is the same idea as a watercolor block. Tape down all sides of the paper (overlapping the tape about ¼ inches onto the paper) onto a hard surface, such as a plywood board. Be sure to test the tape on the paper before doing this, as some papers will tear while removing the tape.

3. HEAVY BOOK: After painting, once the paper is reasonably dry but not completely dry, place the paper under a heavy book and allow it to stay there overnight. The only drawback to this method is that if the paper was too wet, the paint will smear or take on the texture of the book. If it's too dry, the book will have no effect. The perfect time to do this is when there is no discernible sheen to the paper, but it still remains slightly cool to the touch. (I touch the back of the paper.)

4. UPGRADE TO A HEAVIER PAPER: This is the easiest, but not the most cost-effective method. If you've been using 140 lb. paper, upgrading to 300 lb. (640 gsm) will eliminate warping.

Unwanted Hard Edges

Hard edges, though sometimes a good thing when done intentionally, can be distracting in the middle of a flat wash. There are several reasons a hard edge can form:

1. A wash will spread wherever there is damp paper. If your paper is unevenly damp pigments will disperse unevenly and spread only in the damp areas—resulting in a hard edge. Note that wherever you allow your brush to linger (usually at the end of a stroke or when changing directions) you may create a pool of water that will result in a hard edge when dry. You can remedy this by using a slightly damp brush or the edge of a paper towel to soak up the excess paint.

2. When you have too much water on your brush and then apply it to paper, it will dilute the pigment that is already on the paper and cause it to disperse. When it dries, it will leave a hard edge. Remember to slide your brush gently across the rim of your water container to release excess water and blot it on a clean towel if necessary.

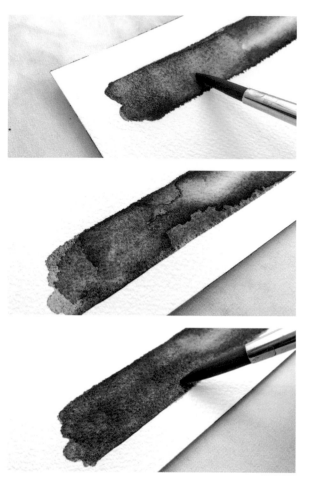

3. Paper that is too absorbent will cause all the water to soak in and leave the pigments at the surface, creating a hard edge. Paper that is not absorbent enough will cause the water, and therefore pigment, to pool and create a hard edge when dry. To avoid this, I recommend always sticking to a professional grade cold press paper for smooth blends.

If you've created an unwanted hard edge, it doesn't mean you have ruined the painting. You can embrace the nature of watercolor, or you can blend it out, but you must do so with care. I recommend doing this in smaller areas, because applying these techniques with a large area may create more issues.

METHOD 1: Use a damp brush to gently wet the area in question. Lightly blend the area with gentle back-and-forth strokes. Essentially, you are lifting from the area with more pigment and evenly distributing it throughout the rest of the painting.

METHOD 2: Load your brush with a small amount of paint in the same color or darker than the color of your painting. Lightly paint over the problem area while blending over the hard edge. Note that this will create a layering effect and darken the entire area.

Uneven Washes

Sometimes you'll set out to paint a flat wash and then when it dries you'll notice it looks uneven. Parts of it may have more paint than other parts, or there may be streaky lines throughout the wash. There are a few reasons why this might happen.

1. Your brush may be too small. A smaller brush requires more strokes to fill up an area of space compared to a larger brush. Switch to a larger brush to remedy this problem.

2. If the amount of water throughout a wash varies, then paint will not settle evenly. The areas with too much water will dilute the paint whereas pigment will collect in the areas with very little water.

Wet-on-Wet Technique Issues

I get a lot of questions about wet-on-wet techniques. If you're having trouble with this technique, you're not alone! In fact, after years of painting in a more realistic style, I had a really hard time with loose painting. Everything was a blob! The number one tip I can give anyone is to be patient while painting. Add your paint to a wet-on-wet wash at the right time to get the right effects. Here are a few things that could be causing the issues:

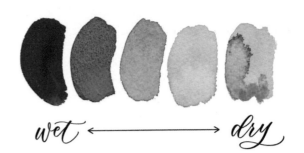

Too much water: You go to apply paint to a wash, but the paint doesn't disperse. This is because your first wash is too wet. Wait and allow the puddle to dry to a nice sheen on your paper, or use less water when applying the first layer. The best time to add the second color when using a wet-on-wet technique is when the wash on your paper still appears shiny, but there is no obvious raised pool of water on the paper.

Too little drying time: You go to apply paint next to a wash and it bleeds into the adjacent wash. This may create a muddy wash. Though this can be used to your advantage, it can pose a problem and muddy a painting if it wasn't intended. Allow your first wash to dry completely (no sheen on paper) before adding a second color next to it.

My Painting Looks Like a Blob

If you are noticing that your paintings lack real definition, it is likely due to a combination of things.

1. Wet-on-wet technique issues (see above).

2. Not using a range of values. Recall the section on color value. Painting in only one range of values makes it difficult for the eye to discern where there is light, shadow, and separation between forms. Remedy this by adding more of a range to your paintings.

Stray Marks

Though some stray marks are just too big and can't be fixed, smaller ones can be removed:

METHOD 1: FLOOD AND LIFT: Though you can use this method on dry paint, it works more easily on paint that is still damp. If you have made a stray mark and want to use this method, work quickly before the paint dries.

1. With a clean brush, apply clean water to the mark.

2. Use a paper towel, rag, or a dry brush and gently press on the mark. Repeat steps 1 and 2 until paint has completely lifted. You may have to scrub gently with clean water. But do so with caution, so as to not tear the paper.

METHOD 2: CUT AND SAND: If you have a stray mark close to an area that has been painted, you may not want to use Method 1. For areas like this, I like to use a precision knife and sanding eraser. Not all paper types can handle this and it would be a good idea to test on scrap paper first.

1. Use the sharp tip of a precision knife to gently scrape away the unwanted mark.

2. Use the sanding eraser to *gently* smooth the paper. Rub in small circular motions to sand the paper. Do not do this while the paper is wet, as it may cause the paper to pull or tear.

3. Repeat steps as necessary.

Artist Tape Is Tearing My Painting

Some paper tears more easily than others. It can be a paper quality issue (I find lower-quality paper tends to tear more easily), but it can also be that your tape is too sticky. It's always a good idea to test the tape on a scrap piece of paper before using it. One thing I always do is to take the tape and stick it somewhere else before sticking it on my paper. It may sound a little strange, but I always stick the tape on my arm, leg,

or on a lint-free cotton shirt before sticking it to my paper. This makes the tape less sticky and prevents tearing.

Washi tape is one of my go-to tapes for painting. If you plan to use tape on your paintings often, I don't recommend this route as it's not very economical. But if you do find a good deal on washi and plan to use it sparingly, it is a good alternative.

My Splatter Drops Are Too Big

There's nothing worse than finishing a painting and adding splatter at the end and having it ruin the painting. If possible, dab away the splatter with a clean towel while it is still wet. Next, use the flood and lift/cut and sand methods to remove stray marks if necessary. Allow the painting to dry completely. Next, check your paint mixture. Usually, large drops of splatter occur if there is too much water in your paint mixture. Otherwise, try using a smaller brush.

Brush Hairs Dried Out of Place

If you forget to reshape and dry your brush flat after each painting session, the brush hairs can remain out of place. Here are a few ways to try to get them back in place:

SYNTHETIC HAIR BRUSHES. Dip the brush head in very hot water. Swish back and forth a few times. Remove from the hot water. Gently remove excess water by patting the brush on a clean towel. When it has cooled enough that you are able to touch it, gently reshape the brush hairs. Wrap the hairs with a small piece of bath tissue or paper towel. Place the brush on its side and allow it to dry. The bath tissue will soak up the extra water and as it dries, it should constrict and stiffen, leaving the hairs to dry in place. Remove the tissue once it is dry. *Do not try this with natural hairs.*

NATURAL HAIR BRUSHES: Wet the brush with clean warm, *not hot*, water. Pat the brush on a clean towel to remove excess water. Gently reshape and wrap with a small piece of bath tissue or paper towel. Place the brush on its side and allow it to dry. The bath tissue will soak up the extra water and as it dries, it should constrict and stiffen, leaving the hairs to dry in place. Remove the tissue once it is dry.

You may read tips that say to use hair gel to reshape the brush hairs. I strongly advise against this as hair gel contains alcohol and this will strip the natural oils from the hairs on your brush, leaving them dry, brittle, and prone to breakage.

Acknowledgments

There were so many people who contributed greatly to the making of this book and to my art career.

First and foremost, I would like to thank my mother and father for always supporting and encouraging my many, many endeavors. My mother, for her grit and for showing me by example how to face adversity and never give up. My father, for his foresight and for teaching me to strive to be my best self.

Thank you to my sister and brother-in-law, Jennifer and Justin, for their incredible generosity and support, and especially to my sister for her thoughtful actions and encouraging words. And thank you to Caden and Evelyn for playing with Harper so I could write this book.

To my brother, Jason, who paid for my art classes back when I wasn't sure if I wanted to learn again: thank you for always believing in me. To my sister-in-law, Audrey: you've overcome so much and continually inspire me with your strength.

Thank you to Leslie for being my official soundboard, looking at every rendition of every painting, and encouraging me through it all. And a big thank you to her husband Jeff, who helped me with all the legal details.

Thank you to Grace Song for suggesting my name and cheering me on.

Thank you to Bridget Thoreson for so kindly guiding me through this entire process. Thank you to Shayna Keyles for her thoughtful editing. And to everyone else at Ulysses Press who contributed to the making of this book: thank you.

To all my Instagram family and friends: you took the tiny creative spark inside of me and ignited a flame. I am eternally grateful.

And the biggest thank you to my husband Andrew. Thank you for seeing me the way that you do and for loving me the way that you do.

About the Author

Jess Park is a California-based artist whose work is best described as playful and colorful. She pulls inspiration from the colors and shapes of the beautiful natural world around her. Her loose watercolor and modern calligraphy style have attracted partnerships with companies such as Princeton Brush, Co. Sakura of America, and Strathmore, but Jess also enjoys creating custom artwork.

As a predominantly self-taught artist, Jess understands the challenges facing budding artists and is passionate about teaching and encouraging other artists through social media, lettering guides, and online and in-person workshops. She believes it is of utmost importance to have fun while creating and works to spread this positive message through her Instagram work (@jeshypark)!